IMAGES
of America

ITALIANS IN HAVERHILL

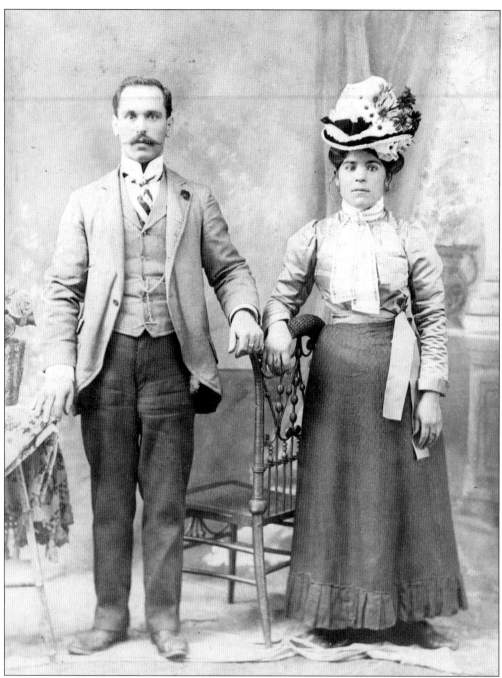

Andrew DeCesare, left, and his sister Louisa (1877–1934), right, were from Cianello, Caserta, which is directly north of Naples. They landed in Boston in 1900, and the family story is that Sabatino Fantini (see page 39), who was on the pier that day, saw her and fell in love at first sight. Louisa married Sabatino after a brief courtship. They lived in Lawrence for a few years and then moved to Haverhill. Louisa's brother Andrew continued to live in Lawrence. A year after Sabatino died in 1924, his brother's wife, Josephine, also died. Louisa took in Josephine's youngest child, Joseph, and raised him along with her children until her own death in 1934.

IMAGES
of America

ITALIANS IN HAVERHILL

Patricia Trainor O'Malley, Ph.D.

ARCADIA

First printed in 2001.

Published by Arcadia Publishing,
an imprint of Tempus Publishing, Inc.
2A Cumberland Street
Charleston, SC 29401

Printed in Great Britain.

Library of Congress Catalog Card Number: 2001088690

For all general information contact Arcadia Publishing at:
Telephone 843-853-2070
Fax 843-853-0044
E-Mail sales@arcadiapublishing.com

For customer service and orders:
Toll-Free 1-888-313-2665

Visit us on the internet at http://www.arcadiapublishing.com

On the cover: The girls from Tuscany (see page 37).

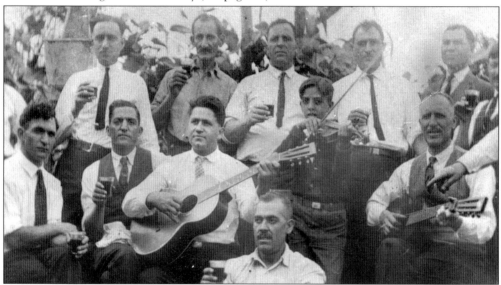

Michele Lupi loved music. He was a songwriter and one of the first members of the Italian Band. So, it was only natural when he bought some land "out in the country" on Studley Street, near the old Tilton's Tower, he would invite his friends to join him and make music. They would play cards, eat, drink wine, and entertain themselves, and Michele would be sure to bring along his young son, Edolo, to play his violin. From left to right are the following: (front row) Michele Lupi; (middle row) Amedeo Villetta, Enrico Spera, James Tarzia with guitar, Edolo Lupi with violin, and Brillante DeVito with guitar; (back row) Ferdinando Caputi (partially hidden), Pietro Falluchi, Nunzio Ciarletta, Orlando Fiorentino, Donato DiPietro, Vincenzo Calvani, and Giuseppe DeScano (partially hidden).

CONTENTS

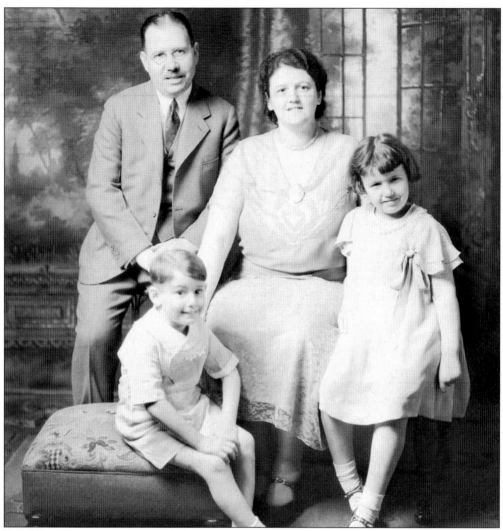

Dr. Albert Consentino was an Italian success story. Born in Italy in 1898, he came with his family to Lawrence at the beginning of the 20th century. He graduated cum laude from Tufts University School of Medicine in 1923 and two years later married Delia Araldo (see page 19). The Consentinos were leaders in both the local Italian community and in the greater Haverhill community. Dr. Consentino, a cardiologist, was in practice from 1927 until his death in 1973. He was a founder of the Italian Welfare Society during the Great Depression, a musician, and a member of the school committee for 20 years. He is shown with his wife, Delia, and daughter Eleanor. His son Albert Jr. is in front. Another son, Philip, was born after this photograph was taken (see page 127).

This book is for all those who claim Italy as their motherland and for the rest of us who share their love for all things Italian.

INTRODUCTION

Why is someone with the Irish name O'Malley writing a book about Italians? Ah! Good question. Simple answer. History is history. The research techniques are the same whether the topic is one of lifelong familiarity or something totally new. The subject of the Italians in Haverhill does not quite fit the latter description. The Italian immigrants and their descendants have been my friends and neighbors all my life in this city, and I have studied and taught the history of Europe for almost half a century.

What I did not know were the hundreds of individual stories that would make up the photographic collage planned for this book. Collecting those stories and the photographs that would illustrate them was the challenge. The Italian community came through with the pictures and the stories. Research in local and national records fleshed out the tales. The results are displayed in the following chapters.

More than 200 families have been profiled. Where possible, I have included as much vital information as could be obtained in the limited time available to produce this book. Four of the five chapters have been organized along the theme of the place of origin of Haverhill's Italians. The division was not difficult to make, since it became very clear that the overwhelming majority of these families were either from the areas around Genoa or Naples, from Abruzzi or Calabria, or from Sicily.

Italian immigrants were no different from the other ethnic groups that come to Haverhill: like followed like. People went to those places where they knew they would find relatives or former neighbors. Thus, the reader of this book will find such place names as Bisegna, San Pietro a Maida, and Grottominarda repeated over and over again.

Italians emigrated from their homeland for the usual reasons that any people came to America: the push of difficult economic conditions and the pull of the search for a better life. There was also the added push from Mother Nature in the form of a series of earthquakes, tidal waves, and volcanic eruptions in central and southern Italy. There were also political reasons. The first Italian immigrants to Haverhill had left, in part, because of the political upheaval that accompanied the efforts by Garibaldi and Cavour to unify Italy. A later generation became disaffected with the Piedmontese domination of government that followed the creation of modern-day Italy, and, finally, there was a series of minor wars as Italy attempted to join the great powers of Europe in its expanding imperialism. All of these economic, political, military, and natural factors made immigration to America preferable to life in the old country.

In a previous work, *The Irish in Haverhill*, I presented an immigrant group that shared many of these same reasons for leaving its homeland. One major difference between the two ethnic groups does stand out. Italian immigration in the 19th and early 20th century was male dominated. Whereas Irish women were much more likely to travel across the sea on their own, Italian women were bound by social customs to immigrate with family, never alone. Irish women went into domestic service. Italian women were discouraged from doing so. Although

many Italian wives and daughters could be found in Haverhill's shoe shops and textile mill after World War I, it is very rare to find any so employed in the decades before the war.

It was also not uncommon to find that married Italian men would leave their families in Italy and come to America alone. Here they would live in boardinghouses and attempt to save their money. For some, the goal was to save enough to bring their families over. For others, the ultimate goal was to return with their American funds to create a better life in their homeland. Relatively inexpensive steamship rates made it possible for some to make frequent visits back and forth across the Atlantic.

The Italians in Haverhill went from pushcart peddlers to business owners in one generation. When the shoe manufacturers in town began to build their new, larger factories in the open fields along River Street, that drew more Italians to Haverhill and led to the rapid buildup of the area. Word of the new jobs and the new housing flew back to Italy and attracted yet more kinfolk and former neighbors to swell the numbers.

The Italians took care of each other through their fraternal societies, such as the Victor Emanuel, the Vita Nuova, the Italian Welfare, and the Italian Citizens Societies. They socialized at the Garibaldi, the Universal Social, and the Liberty Clubs. They entertained each other with their music and fed each other at their picnics and in their restaurants. When they had trouble finding financial help to buy homes, they established their own credit union.

This book makes no attempt to tell the complete story of the Italians in Haverhill. That would take many volumes. However, it should serve to stir memories and remind all who read it to remember all those who made the long voyage from "bella Italia" and the children and grandchildren who carried on their legacy.

Acknowledgments

Italians in Haverhill owes much to four people. Carmine LoConte, on behalf of the Victor Emanuel Lodge, Sons of Italy, took the responsibility of persuading people to share their precious family photographs with me. He did his job so well that I received enough photographs to do three volumes. Salvatore Amari has been collecting and organizing the history of the Italians for decades. The newspaper articles he has copied and the photographs he has saved proved a treasure trove of information. Michael Paolino volunteered his research skills, and I put him to work making telephone calls and knocking on doors, seeking further details on pictures already submitted and looking for yet more photographs to expand my choices.

Finally, and most importantly, I owe a tremendous debt of gratitude to Robert J. Gardella. He handled the endless job of tracking down marriage and death records and scrolled through countless rolls of microfilmed newspapers in search of obituaries. He became a familiar face at the Haverhill City Hall and the Haverhill Public Library and saved me many hours of work. Thanks, friends!

One

NORTHERN ITALY

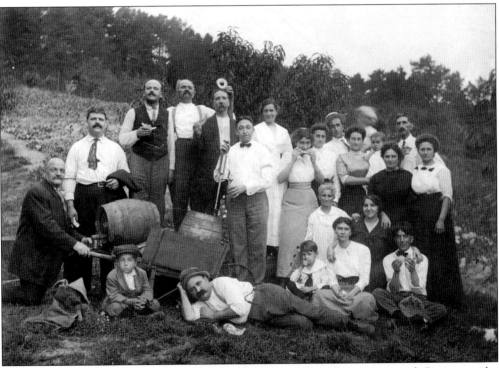

The first permanent Italian settlers in Haverhill came from the area around Genoa on the northwestern coast of Italy. The Gardella brothers (Antonio Stefano and Francesco) and their brother-in-law Lorenzo Gardella established homes and businesses in the city in the 1870s. Over the next two decades, they were joined by relatives and neighbors from their home area in Liguria. This picnic gathering dates from c. 1912. Seated in the front row on the far right are Rose Oneto Gallerani and her cousin Andrew Oneto. Kneeling on the far left is Antonio Gardella. Standing fourth and fifth from the left are Stefano Gardella (with suspenders) and Joseph Foppiano. Annie Oneto is the young lady eating melon. Standing to the right of Annie are, from left to right, Catherine Leone Bassani, John Gardella (holding son Frank), and Rosa Gardella (holding son Raymond). On the far right in the white blouse is Mary Leone Oneto.

Antonio Stefano Gardella (1844–1937), right, was born in Neirone, Genoa, the second child of Josephus and Maria Gardella. As a young man he fought with Garibaldi in Italy's wars of independence. Stefano immigrated to New York in 1870 and, in the same year, married Luigina Innocenza (1849–1943). Their two surviving children of four, Joseph and Rosa, rear, were born in New York. Stefano moved to Haverhill in 1873 and began a fruit business with his brother. He operated a boardinghouse and engaged in numerous businesses. He was a founder of the Garibaldi Club and first treasurer of the Victor Emanuel Society.

Francesco Gardella (1851–1937), the younger brother of Antonio Stefano, married Maria Celestina Garavanta (1854–1890), the daughter of Carlo and Maria Garavanta. They were parents of four boys and two girls. Both girls, one son, and Celestina all died before 1900. Frank and his three surviving sons established a fruit store on Main Street, Haverhill. He was a leading figure in the Italian community, and his funeral was described as one of the largest in local memory. From left to right are Michael (1883–1960), Francesco, Joseph (1888–1953), Celestina, and John (1881–1972). Standing to the rear is Maria Rosa (1878–1896).

Lorenzo (Lawrence) Gardella (1851–1919), the son of Antonio, emigrated from Genoa to New York in 1869. That same year, he married Maria Ludavica Gardella, the sister of Stefano and Francesco. Their first two children, Mary and John, were born in New York. Nine more children were born after they moved to Haverhill: Elizabeth, Amelia, Rose, Joseph, Nettie, Julia, Theresa, Jennie, and Charles. All 11 children were alive when Maria Ludavica (Mary Louise) celebrated her 91st birthday in 1940. Lorenzo operated the first Italian-owned bar in Haverhill. He also had a grocery store with his son-in-law Emilio Senno.

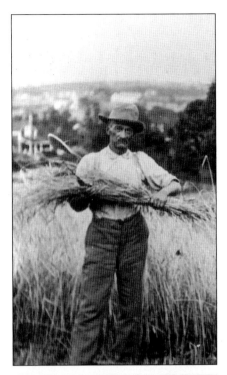

All of Francesco Gardella's siblings gathered in Haverhill on August 7, 1932, for his 81st birthday. Brother Antonio Stefano and his wife, Luigina, are on the left. Sister Rose (1854–1933) is seated next. She married Peter Botto (1837–1917) in 1870, the year they both immigrated. They had nine children, five of whom survived. In the center is Francesco and next to him is Maria Magdalena (1859–1935). She was the wife of Michael Casazza (1852–1920) and the only one of the siblings born in America. The Casazzas were married in 1882. Maria Magdalena bore 15 children, but only three survived. Michael Casazza owned a fruit store on Washington Street. Seated on the far right is Maria Ludavica Gardella (1849–1946), the longest-lived of these hardy siblings.

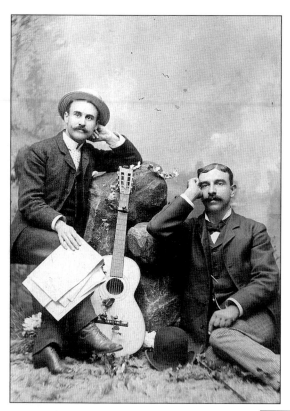

Nicholas Oneto, right, was a founder and first president of the Victor Emanuel Society. He was the son of Louis and Rose (Chiesa) Oneto of Camogli, Genoa, and the brother of Gaetano Oneto and Giuseppina Oneto Parodi. His wife was Laura Senno, and they had three children: Louis, Mary/Mrs. John Olivari, and Elizabeth—all born in Massachusetts in the 1880s. His date of death is not in the Haverhill records, but he survived his brother Gaetano, who died in 1927.

Gaetano "Guy" Oneto (1853–1927), brother of Nicholas, immigrated in 1881 and married the same year. He and his wife, Mary (born 1865), had two daughters: Laura and Rose/Mrs. Philip Gallerani. Gaetano had a fruit and produce business on Washington Street. He was a charter member of the Victor Emanuel Society. Mary died before the 1910 federal census was taken, for Guy is listed as a widower living with his brother Nicholas's family at 50 River Street.

Giovanni (John) Parodi was born in Genoa in 1847, immigrated in 1879, and married Giuseppina Oneto (1865–1942) in 1882. They had three children. Their son Natale (1887–1974) was the first person of Italian descent to graduate from Haverhill High School and to join the Haverhill police force. Their daughter Emma (born 1898) was the first Italo-American to become a public school teacher. John Parodi was a founder of the Victor Emanuel Society in 1891. He was a fruit salesman for many years and died in 1943.

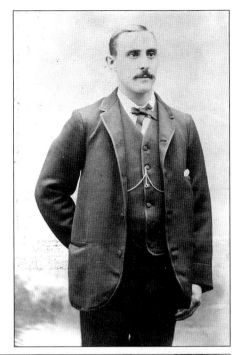

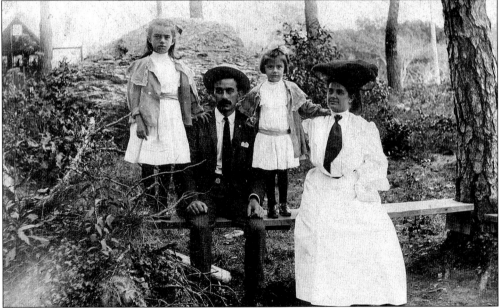

Emanuel Oneto (1870–1924), his parents (Sylvester and Maria Oneto), and three brothers (Frank, Antonio, and Andrew) emigrated from Camogli, Genoa, to Haverhill in the 1880s. Emanuel married Fizia Louise Carbone (1880–1950), youngest daughter of Giovanni Buono and Cecilia Carbone. They had two daughters: Tilly and Delia. For most of his adult life, Oneto conducted a fruit and produce business in Middleboro, Massachusetts. He returned to Haverhill in 1921 and conducted a similar business there until his death. From left to right are Tilly, Emanuel, Delia, and Fizia. Emanuel's mother, Maria, was born in 1839 and died in 1912 in Haverhill.

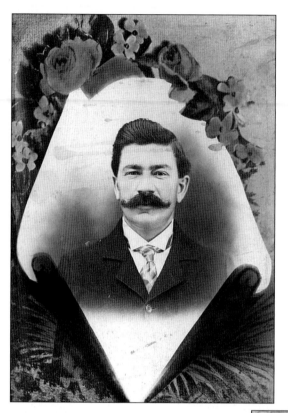

Fortunato (Frank) Oneto (1866–1911) was the oldest of Sylvester Oneto's sons. He married Mary Leone in 1889. The Onetos had two daughters: Carrie, who married John Carbone, and Annie, who married Frank Monte. Frank Oneto was a "lunch peddler." He was a founding member of the Victor Emanuel Society and served on its first executive committee. Frank was 44 when he died in 1911.

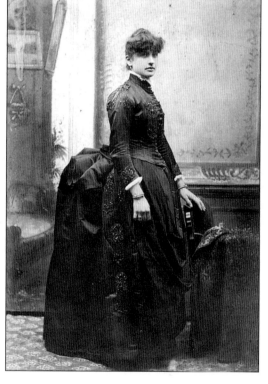

Mary Leone Oneto (1866–1953) was the daughter of Giovanni (1835–1901) and Francesca Leone (1830–1907) of Riorussa, Genoa. Mary immigrated in 1887, followed two years later by her parents, her sister Catherine/Mrs. Carlo Bassani, and her brother Giorgio (1855–1906). This picture shows Mary wearing a magnificent bow-and-bustle dress. The photograph was probably taken to mark her marriage to Frank Oneto in 1889.

Carlo Bassani (1864–1943), seated, was a brick mason who immigrated from Camogli, Genoa, in 1889. He married Catherine Leone (1869–1935), standing, in 1890. Catherine was the sister of Mary Oneto. The Bassanis had two children. John (born 1890), left, married Caroline Bacigalupo (1894–1980). John was killed in action in World War I. His sister Caroline/Carrie (born 1894) was valedictorian of her class at Haverhill High School in 1912. She married John Bacigaloupo of Nashua, New Hampshire. The Bassanis were one of several families to move to Bradford after the construction of the County Bridge made it easier to cross the Merrimack River to their businesses in Haverhill.

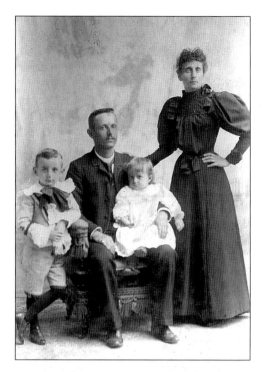

Angelo Bassani (1861–1924) was also a brick mason. He was a cousin of Carlo Bassani and was born in Camogli, Genoa. Angelo married Aurelia Olivari (1871–1953) in 1888 in Genoa. Their first child, Joseph, was born there in 1889. Angelo came to Haverhill in 1890. Aurelia and Joseph followed in 1893. A year later, a second son, Charles, was born. Angelo was the first vice president of the Victor Emanuel Society. The left photograph shows Angelo and Aurelia. The right picture is of Joseph Bassani (1889–1976) and his brother Charles (1894–1974).

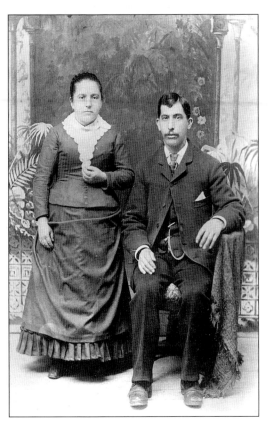

Angelo Giuseppe "Joseph" Foppiano, right, was born in 1851 and was one of the very early immigrants from Italy to Haverhill. He arrived in America in 1872. His wife, Caterina Bacigalupo, was born in 1854 and immigrated in 1884, the same year they were married. The Foppianos had two children, but only a son, George Louis (1887–1973), survived. Louis graduated from Haverhill High School, where he played both football and baseball. Joseph Foppiano was a charter member of the Victor Emanuel Society. He operated a fruit store for many years. Foppiano died in 1938. His wife, Caterina, predeceased him.

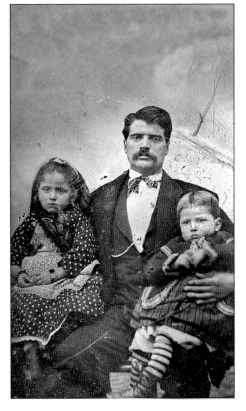

John Garavanta was born in Genoa in 1844. He was a relative of Maria Celestina Garavanta, wife of Francesco Gardella. He married Louise Marsiole in Italy in 1872, and they immigrated to Albany, New York, where their first child, Charles, was born. They returned to Italy, where their second child, Elizabeth, was born and were back in America for the births of their next two children, John and Frank, in Fitchburg, Massachusetts. When their fifth child, Mary Catherine was born in 1886, the Garavantas had settled in Haverhill. The family lived on Primrose Street, near St. James Church, where John had a fruit store. They were among the few Italians who lived outside the River Street–Washington Street neighborhood. Louise died in 1913 and John in 1921. This picture shows John with Elizabeth (1878–1927) and John Jr. (1882–1937) c. 1885.

Joseph Gardella was born in 1875 in Hoboken, New Jersey, to Bartolomeo and Antoinetta Carmella Gardella (1848–1916). His brother Antonio (1878–1963) and two sisters, Angelina/Mrs. Victor Fassio and Rosa/Mrs. John Dondero, also came to Haverhill. Joseph married Elizabeth Garavanta (see page 16) in 1898. They had three children: Paul, Louise/Mrs. John P. Araldo (1901–1992), and Howard (1904–1951). Joseph was a charter member of the Garibaldi Club and of the Victor Emanuel Society. He served as city parade marshall for the 1910 Columbus Day parade, which marked the first national celebration of that holiday. Gardella was a liquor dealer with establishments on River Street and Washington Street. He was also a shoe manufacturer, associated with the Clinton Shoe Company and the Wachusett Shoe Company. Joseph died in 1963 at his home on North Avenue.

Antonio Gardella (1878–1963) was born in Neirone, Genoa, after his parents returned to Italy from New Jersey. He came to Haverhill in 1898 to join the many other Gardella families already there. A few years later, he married Rose Gardella and they had two daughters, Clara (1904–1992) and Catherine (1906–1986). When the girls were young, their mother became ill and Gardella returned his family to Italy in the hopes of a cure. Gardella came back to Haverhill but left his family in Neirone. Rosa died, and two daughters remained in Italy until 1921, about the time this photograph was taken. Clara married Domenick Rosatone, and Catherine married Charles Bassani (see page 15).

There were many different Gardella families in the early Italian community in Haverhill, but there was only one Carbone family. However, there were enough Carbone children to make a significant impact. Giovanni Buono (1829–1893) and Cecilia Vicini (c. 1840–1918) Carbone followed their two oldest sons to Haverhill from Recco, near Genoa, Italy. Twelve more of their 17 children immigrated as well. Their name became synonymous with fruit stores. "Mama Celia," left, is shown with her third daughter, Teresa Martini (1866–1953), and granddaughters Sara (born in Italy, 1894) and Mary (born in Italy, 1892). Teresa, who was married to Giuseppe (Joseph) Martini (1860–1927), was the last of the Carbone children to immigrate to America, arriving in 1894.

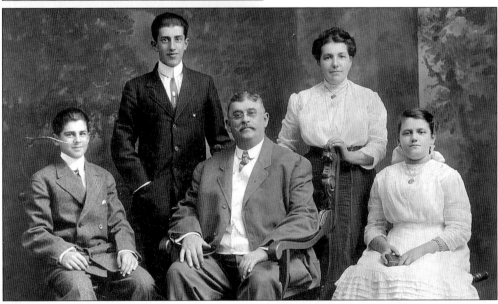

Filippo Domenico Araldo (1856–1931) was born in Salicetto, Piedmont. After immigrating to Haverhill, he married in 1891 the fourth Carbone daughter, Matilde. The Araldos lived for a while in Brockton, Massachusetts, where Matilde's oldest sister, Rose Monte, and her husband had a fruit store. The two younger Araldo children were born in that city. From left to right are the following: (front row) John Philip (1897–1973), who served in the merchant marines in World War I and married Louise Gardella, daughter of Joseph; Filippo Domenico; and Delia (1900–1993), who married Dr. Albert Consentino (see page 6); (back row) Lawrence P. (1893–1961), who served in the U.S. Army in World War I, was in the Civil Air Patrol, and married Anna Bosworth; and Matilde Carbone Araldo (1869–1939).

These are the three youngest of the Carbone children. The picture was taken soon after they arrived in Haverhill with their parents in 1890. From left to right are Federico (1884–1924), who worked with his brothers and was also an actor; Fizia Louise (1880–1950), who married Emanuel Oneto; and John Baptist (1882–1983), who married Emanuel Oneto's niece Carrie.

August Carbone (1874–1964) had returned to Italy to serve his mandatory service in the army. While visiting his family home in Recco in 1903, he met Celestina Bacigaloupo (1887–1972), married her, and brought her back with him to Haverhill. "Gus" owned a store on Water Street near White's Corner. He and Celestina had six children: Julia/Mrs. Arthur Cosio (1904–1997), Alfred (1907–2000), Romeo (1910–1973), Rita/Mrs. Libero Cappabianca (born 1916), Francis (born 1921), and Theodore (1923–1948). During the 1920s, the family returned to live for a number of years in Recco. Two of August's brothers, Charles and Alexander, returned permanently to Recco after World War I.

Fortunato/Frank Berisso and Mary Bernuca married in Recco, Italy, in 1876 and came to America four years later with their son Pellegro (1878–1947), better known as Jean/James. Their daughter Josephine/Josie was born in Philadelphia in 1883. Mary died, and Josie was sent to school in Italy for four years. In the meantime, Berisso married a second wife, Carlotta, and moved to Haverhill. Berisso was a meat cook and later had a restaurant on River Street. He died in 1901, aged 51, and was buried in Philadelphia. Carlotta died in 1915 and was buried in Haverhill. From left to right are Mary, Josephine, Fortunato, and Pellegro Berisso, c. 1885.

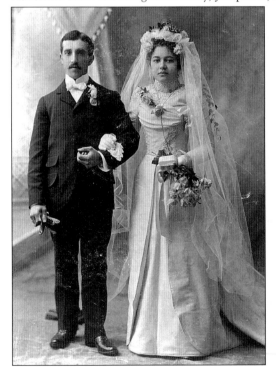

Girolamo/James (1872–1945) and Josie Berisso Carbone (1883–1951) married in 1899. They were parents to five children: Arthur (1900–1966), Edward (1904–1964), Romilda/Mrs. S. Joseph Pepe (see page 93), Wilfred (1912–1990) and Leo (born 1920). Like his brothers, James had a fruit store. His first business was on Water Street. He sold that one to his brother August and opened a new store in the developing Walnut Square area. In later years, his sons added a confectionary store and a gas station to the neighborhood. Josie Carbone, who had studied music during her four years at school in Italy, was the organist for St. Rita's Church at its opening in 1915 and for many years thereafter.

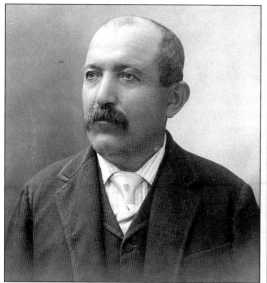 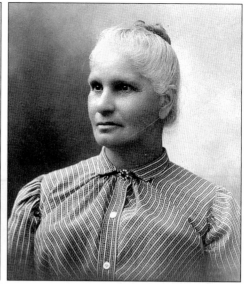

Joseph Casazza (1843–1918) and Louisa Fascio (1849–c. 1913) came from the Genoa area to New York in 1869. They married in 1873. Eight children were born in New York, and five were still alive when the 1900 census recorded them as residing at 152 River Street. Casazza is listed with the unusual occupation of "shoe string peddler." He had been employed in the construction business in New York when a dynamite explosion blew off both of his arms below the elbows. He owed his move to Haverhill and his unusual employment to Louis Barbieri.

Louis Barbieri came from a well-to-do family in Monte Bruin, near Genoa. His sisters were teachers, his brother owned a bakery, and Barbieri was the town banker. He fell in love with one of his employees, but his parents did not approve of the match. So, Louis came to Boston in 1876, started a very successful wholesale fruit business in the North End, and invited his love, Rosa, to join him. She did. They married and had a family. The Barbieris made annual visits to the family villa and Louis's reconciled family. On one of the trips, he met the Casazzas and remained in touch with them. When he learned of Joseph's terrible accident, he invited him and his family to come to Massachusetts, where he set him up in a small business. That is how two of the Casazza sons met the two Barbieri daughters and eventually married them. From left to right are the following: (front row) Mary, Elizabeth, and Louis Barbieri; (back row) Rose Barbieri. The photograph was taken in 1892 in Boston.

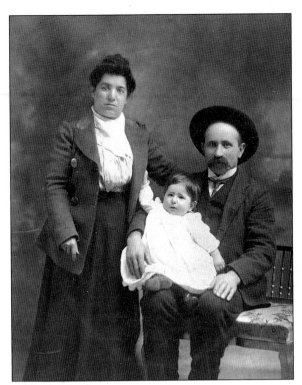

The Casazzas may have moved to Haverhill because there were two other Casazza families there, brothers Michael and John. Joseph and Louisa's oldest child and only daughter was Dusolina, better known as Rose (1875–1932). In 1904, she married widower Vittorio Gardella (1861–1944), who had immigrated in 1875. Vittorio was the son of Antonio and Maria, and his father's name and the year of his arrival suggest that Vittorio was a brother to Lorenzo Gardella (see page 11). Vittorio and Rose had one son, Anthony (1905–1975), who owned the Haverhill Rubber Store on Merrimack Street. From left to right are Rose, Anthony, and Vittorio.

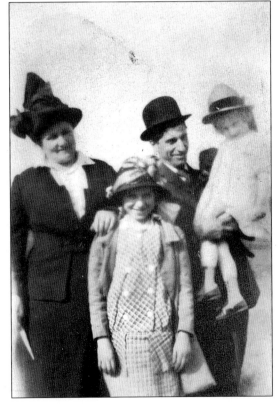

Edward Casazza, born in New York in 1879, was the oldest of the four sons of Joseph and Louise. He and his brothers worked in the shoe shops on River Street. He married Rose Persico in 1898. She had emigrated from Italy in 1894. They had five children: Katherine, Edith, Joseph, Alice, and Francis. Rose and Edward are shown with two of the children in this c. 1910 photograph.

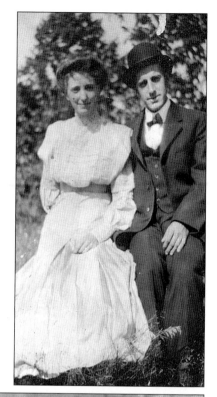

Mary Virginia Barbieri (1883–1951) married Anthony
Joseph Casazza (1880–1930), right, c. 1912. They had
two daughters: Rose/Mrs. William Klueber, a teacher,
and Gladys/Mrs. Bennett MacGregor, a nurse.
Elizabeth Barbieri (1886–1953), below left, married
Victor Casazza (1883–1966), below right, in 1912.
They had two daughters, Eleanor and Julie, and a son
who died in infancy. The two Casazza families shared
a house on Water Street. After working in the local
shoe shops for many years, Anthony and Victor
wanted to set up their own shop in a large barn on
their property. The first cases of shoes were completed
in April 1929—an inauspicious year to begin a
business. Within a year, Anthony died of pneumonia
and Victor closed the shop.

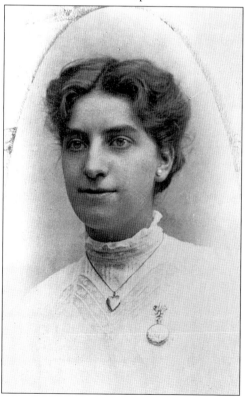

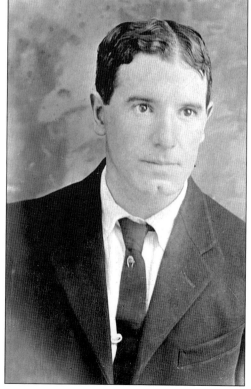

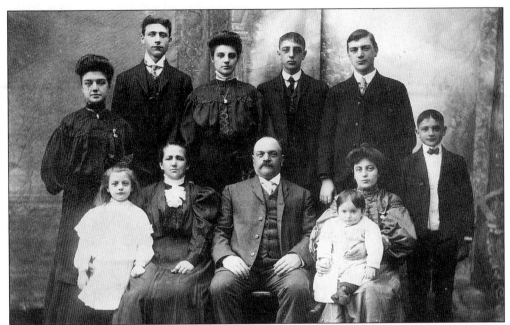

Antonio Gardella was the eldest of a second set of Gardella siblings to settle in Haverhill. Their family home was in Torriglia, Genoa. Antonio (1849–1930) and his wife, Teresa Rouengo (1860–1929), had a roundabout voyage to Haverhill. They met and married in Cuyahoga County, Ohio, in 1875. Son John was born in St. Paul, Minnesota. Daughter Mary was born in New York City. The next four children were born in Haverhill. The seventh and last child, Albina, was born back in Torriglia. The family operated grocery stores in Haverhill for over 80 years, the last one located in Monument Square. From left to right are the following: (front row) Albina/Mrs. Augustus Simpson (1899–1992), Teresa, Antonio, Columbia Carraro/Mrs. John Gardella (1885–1936) holding son Louis (1905–1995), and Nicholas (1893–1963); (back row) Matilda/Mrs. John Garavanta (1885–1974), Albert Gallerani (1878–1916), Mary/Mrs. Albert Gallerani (1883–1915), James (1891–1941), and John (1881–1959).

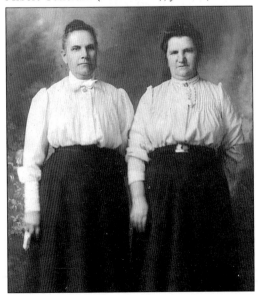

Louise Gardella Ferronetti, left, (1852–1940) and Caroline Gardella Bevelaqua, right, (1858–1942) were Antonio Gardella's sisters. Louise married Charles Ferronetti in Genoa. Their son Victor was born in New York City in 1876. The next three sons—Joseph (1877–1966), John (born 1878), and Antonio (1879–1962)—were born in Genoa. Charles died in 1891. Louise and her sons moved to Haverhill, where in January 1892, a fifth son, James, was born. Son Victor (1876–1930) married Caroline Gardella (1880–1959) in 1898, and they had nine children.

Joseph Ferronetti (1877–1966), son of Louise and Charles (see page 125), married late in life. His wife was Victoria Gardella (1888–1969), the widow of Joseph Gardella. Victoria and Joseph Gardella married in Genoa, where their son Louis was born in 1907. They came to Haverhill in 1909, and a second son, Frank, was born in 1911. Joseph, a shoe worker, died in 1926. Thirteen years later in 1939, Victoria married Joseph Ferronetti. From left to right are Mildred Morello/Mrs. Frank Gardella, Victoria, Joseph, and Charles Ferronetti (1903–1967), son of Joseph's brother Victor.

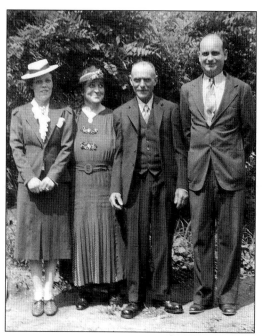

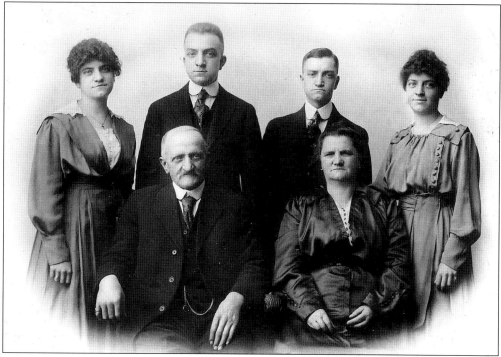

Caroline Gardella and John Bevelaqua (1852–1920) married in Genoa in 1883. They immigrated to New York City, where three children were born who died young. In 1889, they joined Caroline's brothers Antonio and James in Haverhill. The Bevelaquas moved to Central Square, Bradford, where they operated a fruit store for over 60 years. From left to right are the following: (front row) John and Carrie/Caroline; (back row) Santa "Sue"/Mrs. Joseph Coughlin (1893–1968), Anthony (1892–1941), James (1890–1947), and Louise (1897–1967).

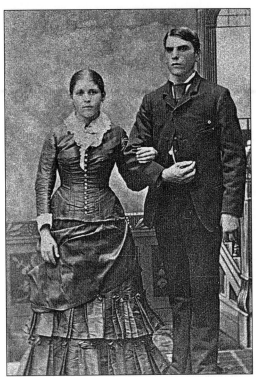

James Gardella (1862–1946) married Caroline Cartamania (1868–1933) in St. James Church, Haverhill, in 1885, the year of this picture. Both were from Genoa. Like his brothers, James was a fruit dealer. He also operated a saloon and sold real estate. The Gardella home was at 590 Washington Street. Their 10 children were Matilda/Mrs. Leon Hayes (1887–1936), Joseph (1889–1946), Catherine (1892–1974), Louis (1893–1972), Charles (1894–1941), Lena/Mrs. Arthur Richardson (1897–1972), Rose/Mrs. James Gallella (1899–1966), Marion (1903–1987), Alfred (1904–1985), and James (1913–1968).

On October 27, 1942, Charles (1863–1945) and Franchesca (1875–1964) Gardella celebrated their 50th wedding anniversary surrounded by their children. They had been married in Neirone, Genoa, in 1892 and came to Haverhill in 1896 with their first child, Jennie, to join Antonio, Louise, Caroline, and James Gardella. A sixth sibling, Margaret Bevilacqua, would immigrate in 1910. From left to right are the following: (front row) Charles, Franchesca, and Jennie (1895–1987); (back row) Victor (1904–1983), Eva (1899–1975), Angelo (1903–1969), Romilda/Mrs. Theodore Gaiero (1914–2000), Anthony (1901–1978), and Frances (1913–1981).

Arcangelo Mortola was born in Camogli, Genoa, in 1879, son of Prospero and Josephine (Cappuro). He is listed in the 1900 census as living with his brother Amedeo and was employed as a laster in a shoe factory. Arcangelo married Amelia Gastaldi (1887–1979) from Salicetto, Piedmont, in 1906. They had one child, Adeline (1907–1970), who married Frank Gaiero (see page 36). The Mortolas lived on Verndale Street, Bradford, where Arcangelo died in 1957.

Margherita Gastaldi (1889–1983) was the sister of Amelia and the daughter of Giuseppe (1851–1921) and Adelaide Bertinasco (1867–1934) Gastaldi. She immigrated in 1900. Margherita married Frank A. Oberti (1885–1944) in 1919. Frank, the son of Antonio and Louisa Baciagaloupo Oberti, was a carpenter who constructed a number of distinctive bungalow-style houses in Bradford and Haverhill. He had the distinction of being not just the first Italo-American from Haverhill to be elected to the Massachusetts state legislature but the first person of Italian descent ever to sit in that body. Frank and Margherita had four children: Margaret/Mrs. Lawrence Masera (born 1924), Frank A. (born 1925), William J. (born 1927), and Louis (1930–1974).

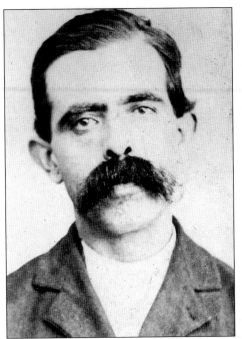

Andrea (1862–1918) and Luigina (1864–1950) Oberti were married in 1887, the year they emigrated from Genoa. In 1900, they lived on River Street. Andrea, left, was a fruit peddler. By 1910, they were on Washington Street and Andrea was a candy peddler. When he died in 1918, the family was residing on Hancock Street. The Obertis had seven children, but only Antonio, John, and Adelina had survived as of 1910.

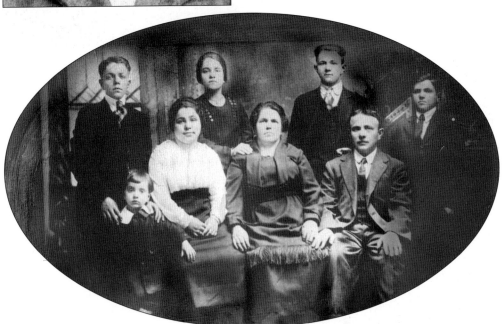

Raffaele/Ralph Gardella (1875–1947), born in Genoa to Michael and Rose, married Jennie Rose Taverna (1877–1939) c. 1899. They lived in New York after immigrating, and that was where their first three children—Lena, Joseph, and Louis—were born. They were in Haverhill for the births of Teresa in 1906 and Andrew in 1908. The family lived on South Street, off Washington Street, and Ralph was a laborer in a shoe shop. His sixth child, Hugo, was born 10 years after Andrew. Hugo Gardella had been married for 63 years to Sophie Porchas when he died in 1999. From left to right are the following: (front row) Hugo, Lena, Rose, Ralph, and Andrew; (back row) Louis, Theresa, and Joseph.

John Gardella (1881–1972) was one of the first children born in Haverhill to an Italian family. His father was Francesco, the pioneer immigrant. His father, John, and his brothers, Michael and Joseph, were in business together in a fruit store at 6 Main Street. John married Maria Rosa Capuro (1888–1930) in Italy in 1908. From left to right are the following: (front row) Rose, Howard (1914–1955), and Raymond (1911–1971); (back row) John and Frank (1909–1984).

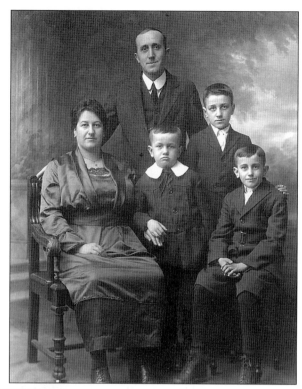

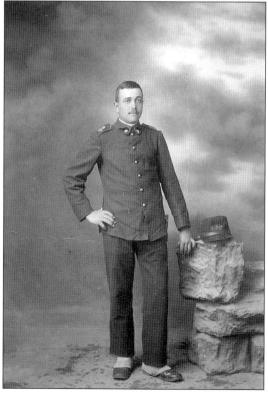

Joseph Gardella (1888–1953) was the third surviving son of Francesco and Celestina. He is shown in the uniform of the Italian army. Many Haverhill Italian immigrants, or sons of immigrants like Joseph, returned to Italy to perform military service to ensure they would not encounter problems when visiting Italy. Joseph served in Italy from 1908 to 1910 and was in the Messina area at the time of the great earthquake. Later, he served in the U.S. Army in World War I before joining his brothers and father in business. He married Josephine Bacigalupo in Chiavari, Italy, during World War II.

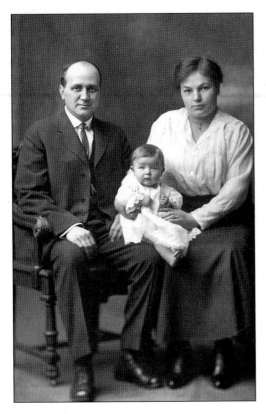

Michael Gardella (1883–1960), middle son of Francesco, married Clelia Bacigalupo (1896–1959) in 1916. Clelia was born in Cicagna, Genoa, the daughter of Angelo and Maria (Gardella) Bacigalupo. She sailed to America in 1911 on the White Star liner SS *Canopic*. The Gardellas had three children: Dora (born 1917), a schoolteacher who married Arthur Hansbury; John A.F. (1918–1989), a detective inspector with the Haverhill Police Department; and Frederick (1921–1994), an engineer. From left to right are Michael, Dora, and Clelia.

Federico Michele Giovanni Bacigalupo (1894–1965) was the brother of Clelia Gardella. He emigrated from Genoa *c.* 1915 and served in the U.S. Army in World War I in France. In 1921, Bacigalupo married Rena Mazzotta (1897–1995), left, who was born in Catania, Sicily. They owned Freddy's Fruit Store on Merrimack Street and had a home in Haverhill's Highlands on Fountain Street.

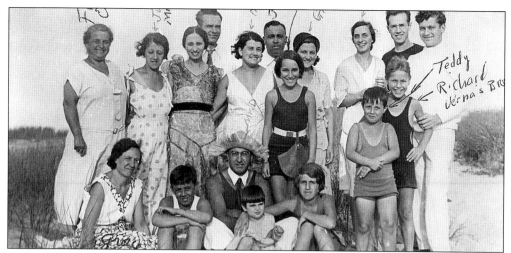

Carbone cousins and friends enjoy a day at Salisbury Beach c. 1929. From left to right are the following: (front row) Grace/Mrs. Joseph Consentino; son Gildo; Dominick DePalma (1898–1986); daughter Eleanor; and Rita Carbone, daughter of August; (middle row) Verna Carbone, daughter of John B.; Teddy Carbone, son of August; and Richard Carbone, son of John B.; (back row) Fizia Carbone Oneto (see page 13); Julia Carbone/Mrs. Arthur Cosio; an unidentified couple; Delia Oneto DePalma (1900–1979), wife of Dominick; Joe Consentino, a cousin of Dr. Albert Consentino; Grace Cappabianca (1903–1972), who taught at the Hannah Dustin School; Lillian (Hale) and Alfred Carbone, the son of August; and Libero Cappabiance (1908–1987), brother of Grace and future husband of Rita Carbone.

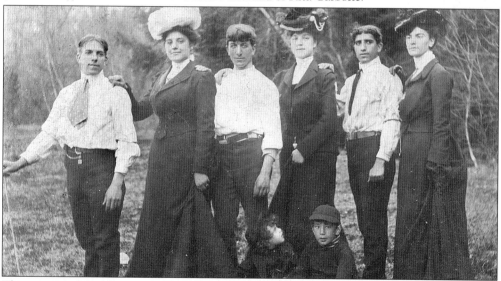

This group of immigrants and children of immigrants appears to have been thoroughly Americanized by the beginning of the 20th century. The two small children seated in front are the correct age to be Albina and Nicholas Gardella, youngest children of Antonio. Standing, from left to right, are John B. Carbone; Mary Gardella/Mrs. Albert Gallerani (1883–1915), the daughter of Antonio; Andrew Oneto (born c. 1882), brother of Frank and Emanuel; Matilda Gardella/Mrs. John Garavanta (1885–1974), sister of Mary (1885–1974); Nicholas DiTomasso (1882–1962), an immigrant from Salerno; and Rose Oneto/Mrs. Philip Gallerani (born 1881), daughter of Gaetano.

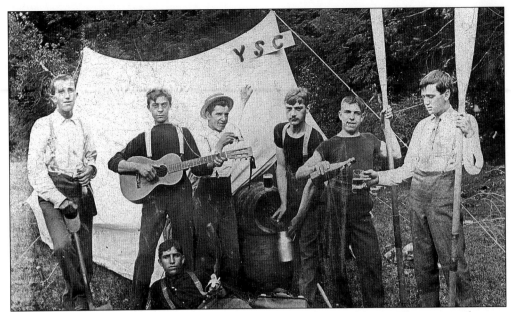

Music, wine, baseball, boating, and good company were enjoyed here! This group of young Italian and Italian-American young men enjoyed *la dolce vita* on a summer's day at the beginning of the 20th century. From left to right are the following: (front row) Nick DiTommaso (see page 81); (back row) John Gardella (see page 10), August Cosio, Victor Casazza (see page 23), John Gardella (see page 24), John Carbone (see page 19), and Michael Gardella (see page 10). All of these young men were born between 1881 and 1883. "Gus" Cosio, the son of Frank and Annie, had immigrated in 1900 when he was 18. This information helps to date the photograph.

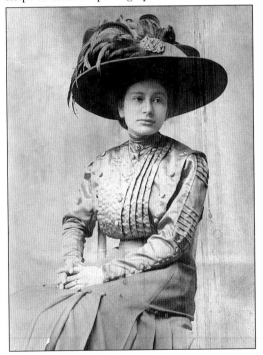

Seated under this magnificent hat is Carrie Oneto (1890–1983). She was the daughter of Frank and Mary (Leone) Oneto. Carrie was part of a lively group of female relatives and friends who called themselves the Floradora Girls. In 1912, she married John Baptist Carbone, coproprietor of the Carbone Brothers fruit store in Washington Square. They had three children: Raymond (1913–1997) who married Dena DiPietro; Verna, a schoolteacher (born 1918); and Richard (1921–1982). The family lived on Leroy Avenue in Bradford.

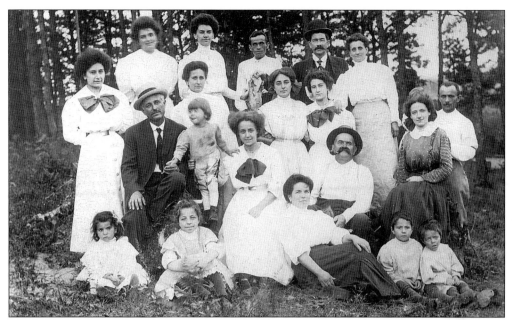

This *c.* 1910 scene shows a Genoese picnic. From left to right are the following: (first row) all unidentified; (second row) Carlo Bassani, an unidentified child, Caroline Bassani, Antonio Stefano Gardella, and an unidentified couple with child; (third row) Carrie Oneto, Mary Leone Oneto, Laura Gardella/Mrs. Mark Dondero, and Annie Oneto; (fourth row) Matilda Garavanta, Rose Oneto Gallerani, an unidentified man with a fish, Frank Oneto, and Catherine Leone Bassani.

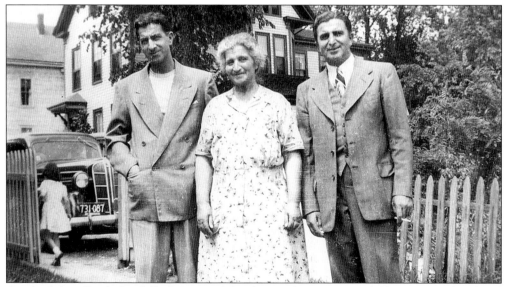

On the left is Frank Gardella (1911–1976), who was born in Haverhill. He married Mildred Morello in 1934, and they had three daughters: Ann, Elaine, and Lynda. Frank was a floor covering salesman. His mother, Victoria Gardella Ferronetti (see page 25), is in the center. On the right is Louis Gardella (1907–1995), who was born in Genoa. He married Katherine "Kitty" Marinaro (see page 101), a schoolteacher, in 1929. Louis was a self-employed carpenter. They had two sons, Arthur and Philip, and a daughter Janice.

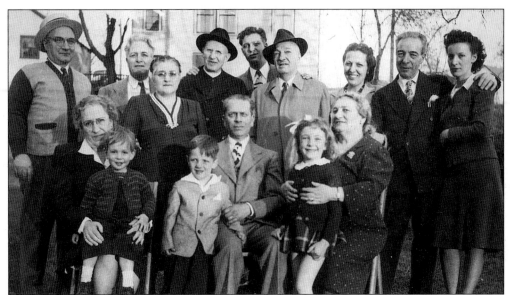

The three Cesati brothers, Ermanno, Arthur, and Rinaldo, emigrated from Genoa. Ermanno and Arthur operated the Cesati Meat Market on Washington Street, and Rinaldo (1881–1948) and his son Pollione/Paul (1904–1967) were the original owners of the Bella Vista restaurant on Pilling Street. From left to right are the following: (front row, standing) Emil, Richard, and Donna Bodwell; (middle row, sitting) Mrs. Arthur (Louise) Cesati, Anthony DeMarco, and Mrs. Ermanno (Clara Ponzini) Cesati; (back row) Ermanno and Arthur Cesati, Maria Ponzini, a clergyman brother of Mrs. Rinaldo (Marcella) Cesati, Paul and Rinaldo Cesati, Emily Cesati DeMarco (1903–1993) (daughter of Rinaldo), an unidentified brother from Italy, and Josephine Cesati Bodwell (daughter of Ermanno).

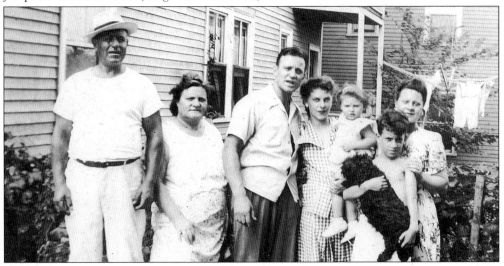

Ernesto and Emilia (Bianchi) Bassi were from Cesenatico, between Ravenna and Rimini in Emilia Romagna. Ernesto was born in 1888 and died in 1946. Emilia was born in 1891 and died in 1965. Both Ernesto and Emilia immigrated in 1912. The Bassis had five children, all born in Haverhill: Aligi (born c. 1913), Hector (1915–1965), Mario (born c. 1916), Mary (c. 1918–1997), and Ida (born c. 1920). From left to right are Ernesto, Emelia, Hector, Helen/Mrs. Aligi Bassi, her daughter Loretta, Mary Bassi Scionti, and Rocco Scionti holding the dog (named Judy).

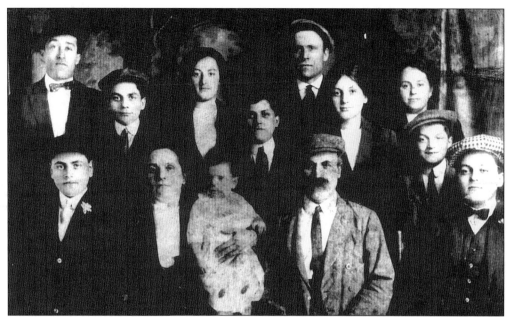

Antonio Zamarchi (1865–1933) married Claricia Pasini (1874–1952) in Santarcangelo, Rimini, in Emilia Romagna. Thirteen children were born and nine survived to maturity. The family immigrated to Portsmouth, New Hampshire, to join oldest child Julia and her husband in 1912. The parents and their younger children were in Haverhill by 1922. Antonio worked as a janitor at the Liberty Club. From left to right are the following: (front row) Silvio (1897–1985), Claricia holding Theresa (1912–1997), Anthony, and Alfred (1895–1963); (middle row) Albert (1899–1977), Joseph (1901–1974), Elvira (1898–1938), and John (1903–1932); (back row) Silvestro and Seconda Zamarchi Brighi (1894–1976), and Frank and Julia Zamarchi Garratoni (1891–1972). Julia, Silvio, and Claricia returned to Italy after Antonio's death.

Orestes/John Zamarchi (1903–1932), son of Antonio and Claricia, was born in Santarcangelo, Rimini, in 1903. He was nine years old when the family immigrated. John married Leonilda Albanese (1903–1990), daughter of Rocco and Carpanella (see page 82), in 1927. Her family came from the Naples area. John and Leonilda had two children: Romilda (born 1928) and Anthony (born 1931). John died at age 29 of spinal meningitis when his daughter Romilda was four and son Anthony was one. The two grandfathers, Zamarchi and Albanese, died in successive years: 1933 and 1934. Grandmother Albanese and the rest of her family helped to raise the Zamarchi children.

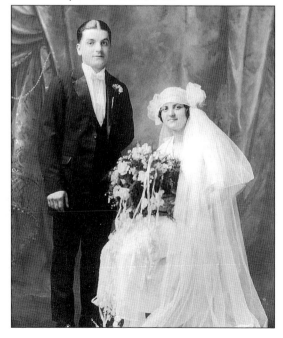

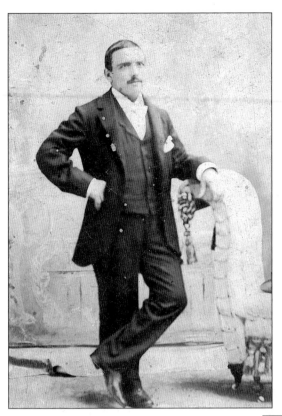

Domenic Gaiero (1873–1964) came from Salicetto, Cuneo, in the Piedmont region of northwestern Italy. He was in Haverhill by 1895, where he became an active member of the Victor Emanuel Society. He was one of the cosigners for the society building at 94–96 River Street. Domenic returned to Italy to marry Mary Rubino (1883–1962) in 1902. The family lived on Primrose Street and had a wholesale fruit and produce business on Essex Street, as well as several grocery stores. Eight of the couple's 12 children survived to adulthood: Louis (1905–1972), Theodore (1908–1982), Frank (1910–1995), Richard (1912–1992), Reverend Romeo (1914–1995), Victor (1920–1987), Domenic (1921–1997), and Mary/Mrs. John Goggin (born 1924).

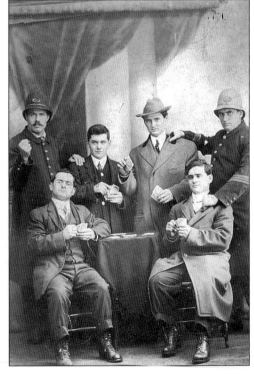

The Grazio brothers, Bartolomeo and Sebastian, were from Cigliano, Turin, in Piedmont. Their card-playing friends included Egidio and Primo Malaguti, seated front. The Malaguti brothers were from Bologna, Emilia Romagna. From left to right in the back are an unidentified man, Domenic Cusano (see page 84), Bartolomeo Grazio, and Sebastian Grazio. Bartolomeo (1880–1948) was a stonemason at the Haverhill Boxboards Company. He and his wife, Jenny (1884–1963), lived on Maxwell Street. Sebastian came to Haverhill with his wife, Mary Fido, in 1902. He did construction work. Primo Malaguti (1883–1952) and his wife, Rose (Tassinari), were living on Willie Street in 1910, near Domenic Cusano. Primo, Rose, and Egidio later moved to 87 Laurel Avenue, Bradford.

Two

CENTRAL ITALY

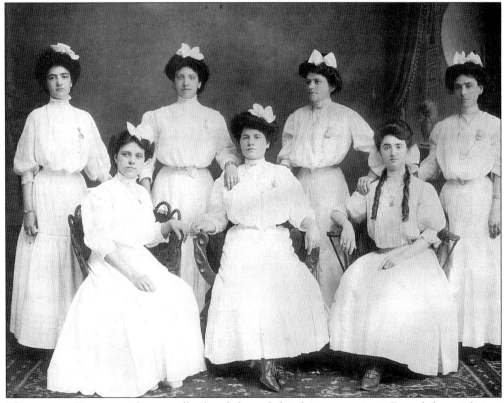

These seven Tuscany girls were all related through kinship or marriage. From left to right are the following: (front row) Sandrina Giusti (1890–1962), Evalina Cioni (1885–1972), and unidentified; (back row) unidentified, Josephine Fazzi (1889–1925), Ferdinanda Conforti (1883–1942), and Carlotta Conforti (1886–1910). It is thought that the two unidentified women were sisters and close relatives of John Conte, who married Evalina Cioni in 1909. That wedding may have been the occasion for this photograph.

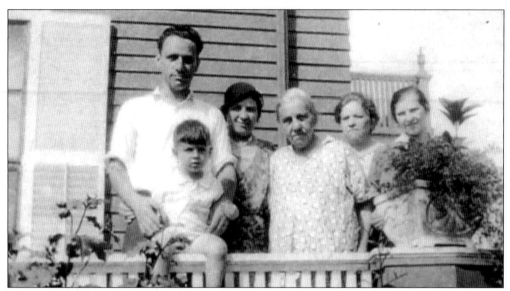

Dusella Fantini Conforti (1866–1934) and family were from Riparbella, Pisa. Dusella married Ricardo Conforti (1862–1936) in Italy. Five children were born there: Ferdinanda, Carlotta, Ferdinando, Alessandro, and Peter. Ricardo moved his family to Brazil where a fifth child, Sven/Zeno, was born. Ricardo's frequent trips back to Italy led Dusella to insist that the family join her brothers in Massachusetts. The Confortis arrived in 1906, and the 1910 census found them living at 40 Hall Street. Another child, Lionel, was born in 1911 but died young. Dusella is shown in this photograph with three generations of her family. From left to right are Peter, Andrew (Peter's son), Clara Bruno Conforti (Peter's wife), Dusella Fantini Conforti, Nanda Conforti Bachini, and Carlotta (Nanda's daughter).

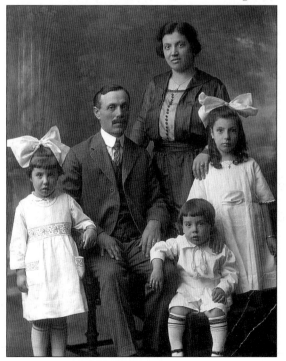

Rinaldo Fantini (1874–1959) was the brother of Dusella. He immigrated from Tuscany in 1896. He was in the bakery business with his brother Sabatino and then went into the grocery business. Rinaldo was also a musician who played trombone and taught music. He married Josephine Fazzi from Lucca, Tuscany. From left to right are the following: (front row) Flora/Mrs. Carmine Cipolla (born 1914), Rinaldo, Aldo (1916–1998), and Alda/Mrs. Carmen Letizia (1912–1967); (back row) Josephine. Children born after this 1918 photograph included Vivian/Mrs. Walter Bastek (1926–1989), Joseph (born 1924), and Joseph's twin who died in infancy.

Sabatino Fantini (1869–1924) was born in Riparbella, Pisa. Few Toscani came to Haverhill; most preferred California. Those who did tended to be related through the Fantini/Conforti family. In the 1910 census, Sabatino listed his year of immigration as 1891, though family history gives 1894 as the date. Sabatino began the family bakery in 1902 on Winter Street, moved to River Street, and then moved to Beach Street. The Fantini Brothers Bakery is now on Washington Street. Fantini married Louisa DeCesare (see page 2) in 1902. They had 10 children. Sabatino died at age 55 in 1924. Three generations of Fantinis have continued the bakery business in Haverhill.

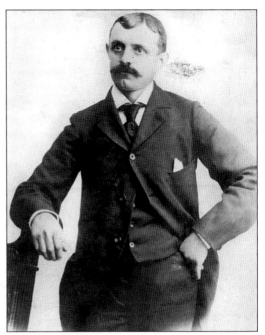

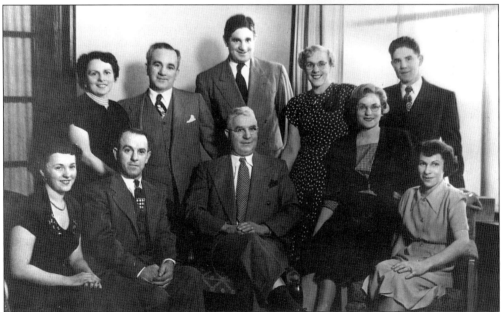

The 10 children of Sabatino and Louisa Fantini posed for this family portrait in 1950. The occasion was the 25th wedding anniversary celebration of their sister Rose and her husband, Ralph D'Arcangelo. From left to right are the following: (front row) Rita (born 1920), who married Charles Buzzell; Alfred (1903–1972), who married Mildred Zakarosky; Alexander (1902–1980), who married Anna Iasimone; Edith (born 1913), who married Harry Delva and (later) Carmen Basso; and Alice (1909–1973), who married Aldo Santarelli; (back row) Rose (1905–1985), who married Ralph D'Arcangelo; Rico (1906–1979), who married Alice Sweeney; Alberto (1915–1976), who married Betty Pascucci; Celia (1908–1995), who married Rocco Flammia; and Ernesto (1912–1979), who married Caroline Mancusi.

Sandrina Giusti (1890–1962) and Alessandro Conforti (1889–1974) are shown in this 1910 photograph. Sandrina was living with Dusela and Ricardo Conforti in the 1910 census. She married their son Allesandro on February 4, 1910. Sandrina immigrated in 1907 and Allesandro immigrated in 1906. They had three children: Alba, Rose, and Richard.

Ferdinanda "Nanda" Conforti (1883–1942) and Guilio Bachini (1881–1942) were living with her parents, Dusella and Ricardo Conforti, in 1910. They had married in 1909 and had a daughter, Iris/Mrs. Michael Basso (1909–1944). Giulio was the son of Felicina Bachini Cioni, from Castelfranco di Sotto, Pisa. He left Italy to move to France and then immigrated to the United States in 1907. The other Bachini children were Carlotta/Mrs. Charles Kershaw (1912–1956), John (1917–1996), Florence/Mrs. Christopher Petrou (1919–1993), and Julia/Mrs. Andrew Rampulla (born 1921).

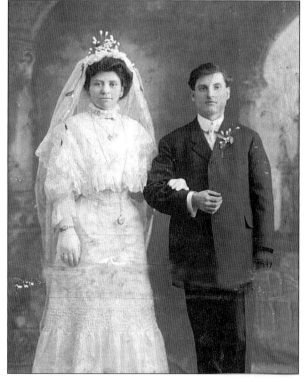

Felicina Bachini (1857–1949), from Castelfranco di Sotto, Pisa, Tuscany, was a widow with two children when she married a man named Cioni and had daughter Evelina. Her second husband was abusive, and since divorce was out of the question, Felicina took Evelina to join her son Giulio in America. The two women stayed for a while in Naples , where they tutored in the Tuscan dialect. They were in Haverhill by c. 1905. They had planned to move on to California, but they lost the address of their fellow Toscani in California, so they remained in Haverhill.

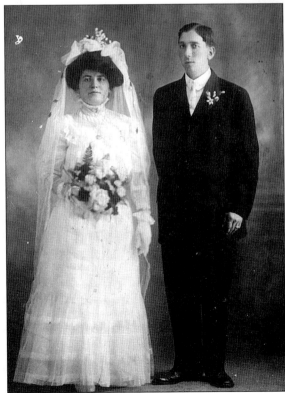

Evelina Cioni (1885–1972) had come with her mother, Felicina Bachini Cioni, to join her brother Giulio Bachini in Haverhill. She was married in 1909 to John Conte from Bisegna, Abruzzi. John was born 1882. He is in the 1900 census, aged 16, living with Raphael and Samuele Conte. All three had immigrated in 1897 and were employed in the shoe shops. Evelina and John had four children: Lillian/Mrs. Samuel Scimia (1910–1993), Olga Orenstein Hannaford (1912–1999), Hugo (1914–1992), and Ann/Mrs. Leslie Sampson (born 1917). John Conte died in 1924 of heart failure.

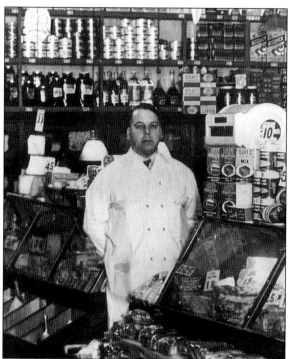

Augusto Fiorentini was born in 1888 in Palestrina, Latium, which is southeast of Rome. He immigrated in 1907 and, in 1915, married Angelina Cipolla (1896–1974). She had been born in Lawrence. Gus had worked as general manager of United Butchers on Merrimack Street before opening his own store, Gus' Market at 2 Washington Street in 1927. He is shown in his store c. 1938. At one time or another, each of his three sons worked with him in the store. He closed Gus' Market in 1960 and opened an IGA market in Salem, Massachusetts.

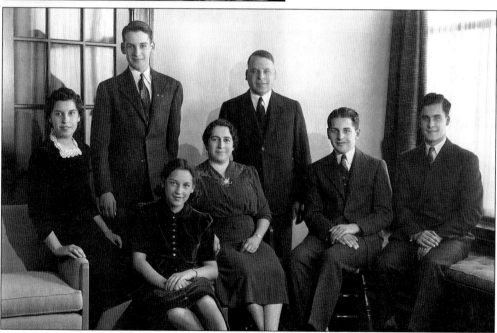

Augusto and Angelina Fiorentini and family are shown at the celebration for the couple's 25th wedding anniversary in 1940. From left to right are the following: (front row) Mary/Mrs. Richard Breault (born 1921); Rita/Mrs. Warren Thuotte (born 1927); mother Angelina Cipolla (1896–1974); John (born 1923), who married Lucy Scamporino; and Francis (born 1918), who married Constance Petralia; (back row) Henry (born 1925), who married Teresa Gesmundo, and father Augusto (1888–1974). The Fiorentini family lived on Garfield Street.

Giacomo Schiavoni and the three Giorgio/George brothers came from Piedilama, Ascoli Piceno, near the Adriatic Sea in Marche. The area is immediately north of Abruzzi. Giacomo, who came to Haverhill first, sponsored the Giorgio brothers. From left to right are the following: (front row) Frank Giorgio/George (1889–1980) and Giacomo/James Schiavoni; (back row) Emidio and John Giorgio/George (1896–1988). Both Frank and John George worked for the University of New Hampshire. Emidio married Mary Schiavoni, sister of James. James Schiavoni was the parade marshal of the 1911 Columbus Day parade.

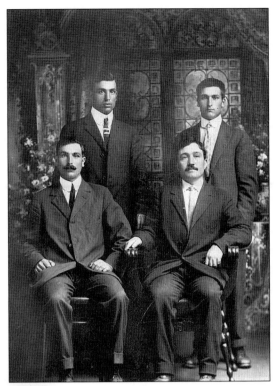

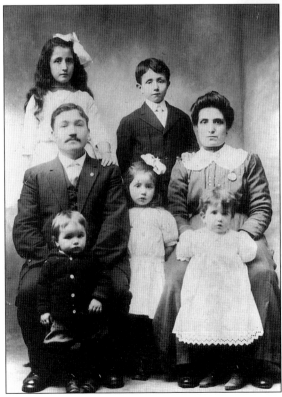

Giacomo Schiavoni (1874–1935) had a barbershop in the Coombs building at the corner of Washington Square and Emerson Street. He married Antoinette Petraccio c. 1902. Antoinette had come to New York when she was six to live with her immigrant father after her mother died. The Schiavonis had 11 children. From left to right are the following: (front row) Frank J. (1911–1987) and Frances/Mrs. Joseph Forte (1910–1946); (middle row) Giacomo, Marguerite (born 1909), and Antoinette (1880–1967); (back row) Anna Marie/Mrs. Bernard Lebro (1902–1953) and Vincent (1903–1971). Four more children were born after this 1912 picture: Robert (1915–1993), Virginia/Mrs. Frank Sawyer (1918–1993), Theodore (1921–1972), and Ernestine/Mrs. John Damon (1924–1954). Vincenzina (1903–1903) and Francesco (1906–1910) died young.

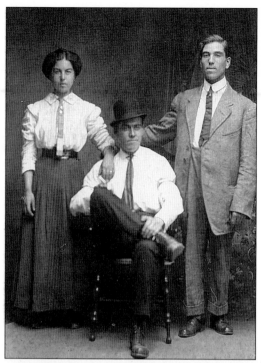

Michele Lupi (1884–1947), seated, was born in Villalago, Aquila, in Abruzzi. He immigrated in 1909 and worked in Haverhill's shoe shops. His wife, Almerinda Caputi (1887–1952), left, came from the same town. She and Lupi were married in 1907, but she did not arrive in Haverhill until 1911. Almerinda's brother Ferdinando/Fred Caputi is on the right.

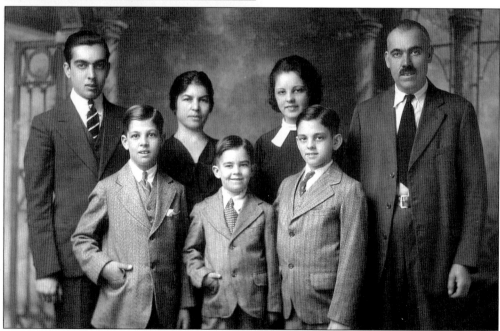

The Lupi family gathered for this photograph c. 1934. From left to right are the following: (front row) Gino (1921–1998), Ernesto (1926–1980), and Romeo (born 1920); (back row) Edolo (born 1912), Almerinda (Caputi), Alda/Mrs. Sebastian Salfia (1913–1985), and Michele. Alda Lupi was chosen Miss Italy by the Universal Social Club in 1930. Edolo married Eda Forte. Gino married Helen Shields. Ernest married Lillian Cronin. A fifth Lupi son, Remo (1914–1932), had died just before this picture was taken.

Paul Pecci was born in Abruzzi, Italy, in 1897. He immigrated to Haverhill in 1915. Paul was a factory foreman. He married Lena Mazzotta (see page 114), a 1916 immigrant from Sicily and they lived on Fountain Street in Haverhill's Highlands. Paul and Lena had one child, daughter Phyliss/Mrs. Dudley Haseltine. Paul died in 1953.

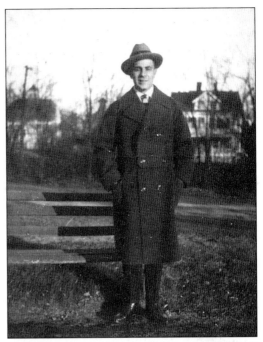

Augusto D'Allesandro (1886–1975), born in Abruzzi, immigrated to Lynn, Massachusetts, when he was 16. He married Marianina Barisano (1888–1976) of Mirabella, Naples, in 1906. Their children were born in Lynn. By 1932, the family was in Haverhill, where Augusto worked at the Becker Shoe Company. In 1947, Augusto and two of his children, Elmo and Yoland, created the Lesande Shoe Company. This photograph was taken at Augusto and Marianina's 50th wedding anniversary in 1956. From left to right are the following: (front row) Augusto; Marianina; Yoland (1907–1957); and Hilda/Mrs. John DiTomasso (1910–1997); (back row) Nina (born 1911); Elmo (born 1914), who married Rita McCarthy; and Agnes/Mrs. Consalvo Sciubba (born 1909). Nina had a twin, Orsina, who died in infancy.

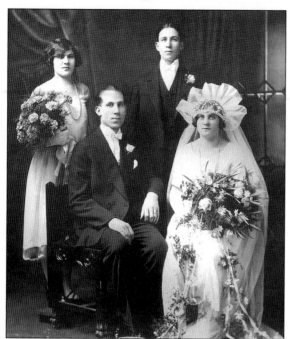

Secondino "Sam" and Rose Buccini Comei were married in November 1925. Sam was born in Bisegna, Abruzzi, Italy, in 1900 and died in Haverhill in 1983. Rose was born in Haverhill c. 1904 and died in 1997. Sam, a shoe worker, was one of the founders of the Italian American Credit Union (see page 126). At his death, he left two sons (Anthony and Paul), two brothers (Domenic and Joseph), and two sisters (Annie Basile and Philomena D'Amato). Rose, who was also a shoe worker, left a sister, Jennie Bologna. The wedding party in this picture includes, from left to right, the following: (front row) Sam and Rose Comei; (back row) Angelina Buccini (Rose's sister) and Frank Comei (Sam's brother).

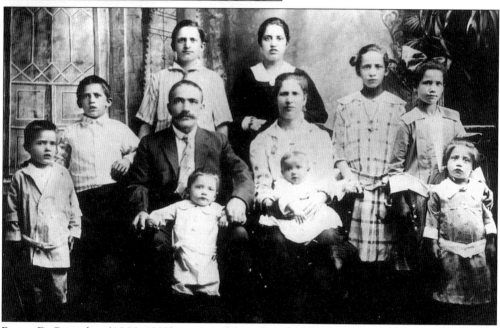

Rocco DeCristofaro (1866–1927) emigrated from Bisegna, Abruzzi, in 1891. He was a grocer for over 30 years with a home on River Street. In 1896, he married Maria "Jennie" Pompa (1877–1950), who had emigrated from the same town the previous year. This picture was taken c. 1918. From left to right are the following: (front row) Albert (1915–1919), Rocco Jr. (born 1916), baby Frances (1917–1988), and Loretta (1914–1982); (middle row) Mario (1912–1928), Rocco, Maria, Jenny (1904–1985), and Helen (1906–1962); (back row) Michael (born 1905) and Elizabeth/Alice (born 1901). Their first child, Louis (born 1898), and Mario, Albert, and Rocco Jr. died when they were young children.

Faustina "Ida" Eramo (1889–1976), from the province of L'Aquila, Abruzzi, immigrated in 1904. She married Dio Graziano Taglieri in 1907 and had five children: John (born 1908), Sabina/Mrs. Andrew Gardella (born 1910), Hugo, (1912–1988), Alice/Mrs. Albert Sciacca (1914–1996), and Nellie (born 1917). Ida is shown, age 14, with her future sister-in-law Paolina Taglieri.

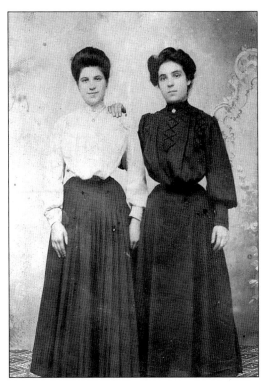

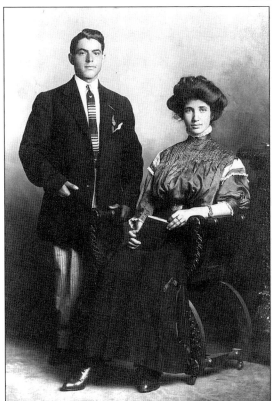

Pasquale Angelotti (1885–1974), the son of Mauro and Teresa (Maino) Angelotti, emigrated in 1906 from Lavello, Potenza, Marche. He married Paolina/Pauline Taglieri in 1909. She was the sister of Dio Graziano Taglieri and Elisa Nissa. Their son Maurice was born in 1911 and died in 1975. Paolina died at 23 in December 1915. Patsy remarried in 1919. His bride was his brother's widow, Rosina (Scatamacchia) Angelotti. She had three daughters: Theresa, Lucy, and Ersilia. Patsy and Rosina had four children of their own: Emma, Mary, Sylvio, and Gina.

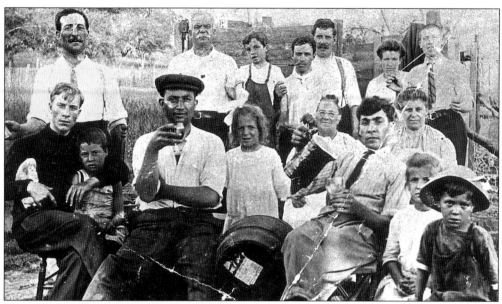

DioGraziano Taglieri (1885–1923), seated with cap, first appears in the Haverhill records as a 15-year-old street bootblack. Also at his 117 River Street address in the 1900 census were his father Gian Domenico, 45, Michael, 20, and Luispranto Taglieri, 18. DioGraziano's sister Elisa Nissi's husband, Leandro Nissi, is standing first on the left. Standing second from the right is Elisa Nissi. The children are Taglieris and Nissis. Both families had a daughter named Sabina, after Sabina Ramputi Taglieri, mother of Dio Graziano and Elisa. The Taglieris were from L'Aquila, Abruzzi. Gian Domenico Taglieri, the elderly man in the back row, died in Haverhill on September 9, 1922, five months before his son who died on February 9, 1923.

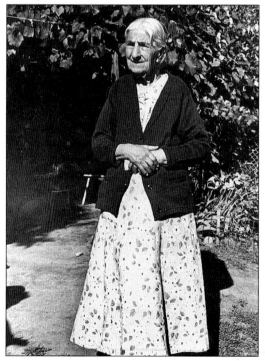

When Dio Graziano Taglieri died in 1923, his youngest child was under five years of age. His widow Ida took on two jobs, one at Allen Shoe and the other at a candy shop on Merrimack Street. To help care for her young children, she asked her mother Mariana Eramo (1863–1951), to come from her home in Abruzzi. There were at least two other of Mariana Eramo's children in Haverhill. The 1910 census lists Patsy (Pasquale) and Fortunato/Frank Eramo residing with the Taglieris.

Frank Eramo (1892–1979), shown in his World War I army uniform, had emigrated from Ortona, Abruzzi, when he was 14 years old in 1906. He was the younger brother of Faustina "Ida" Eramo. Frank married Eva Ferronetti, who was the oldest of the nine children of Victor and Carrie Ferronetti. Frank and Eva had one child, Mary, who married Frank LaManna. Frank Eramo worked for the Haverhill Water Department.

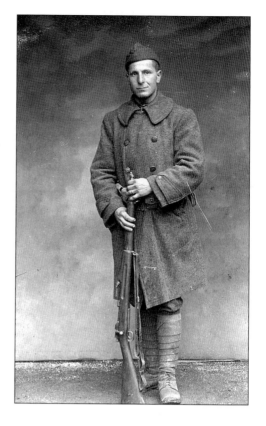

Leandro Nissi (1879–1969), the son of Frank and Carmella (Allecrette), immigrated in 1902. He worked for the electric company and later was a track foreman for Eastern Massachusetts Street Railway and Northeast Massachusetts Railroad. His wife, Elisa Taglieri (1880–1957), immigrated in 1900, the same year as her father and brothers. Leandro and Elisa married in 1904. Their first three children are shown in this c. 1908 picture. From left to right are Eugenia (1906–1999), Nordino/Nordo (1904–1975), and Sabina (born 1907).

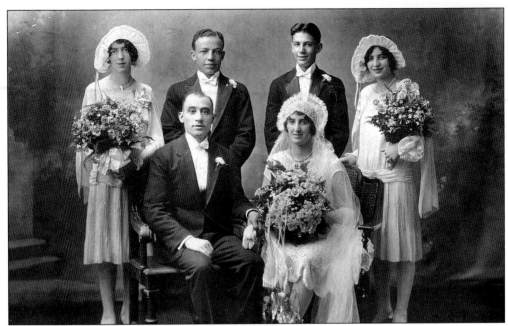

Angelo DelRosso (1894–1967), the son of Paolo (1864–1937) and Domenica (1867–1954), married Eugenia/Jenny Nissi in the 1920s. Three of her siblings and a cousin were attendants at the ceremony. From left to right are the following: (front row) Angelo and Jenny; (back row) Sabina, Nordo, and Frank Nissi (1908–1983) and their cousin Sabina Taglieri (born 1910). Angelo and Jenny had a son, Dr. Remo DelRosso. Sabina and Daniel Rorke had sons Daniel and Robert. Nordo and Mary Rorke had sons Nordo and Richard and daughter Elisa. Frank and Mary Turner had sons Paul and Thomas and daughters Joanne and Carla. Sabina Taglieri married Andrew Gardella (see page 28) and had two children, Elaine and Robert.

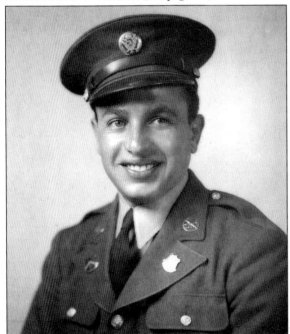

Hugo Taglieri (1912–1988), shown in his World War II army uniform, was the son of Dio Graziano and Ida (Eramo) Taglieri. He was nicknamed "Checko" for his love of the game of checkers. Hugo had a double distinction in the local Italian community. He was one of the first Italo-Americans to join the Haverhill Fire Department and was the first of his ethnic group to become the Haverhill postmaster (1960–1977). Hugo was married to Patricia Doyle.

Nellie Taglieri (born 1917), was the youngest child of Dio Graziano and Ida (Eramo) Taglieri. She was five years old when her father died, and she was raised by her maternal grandmother. Nellie was chosen Miss Italy in 1938 by the Universal Social Club. That same year, she married Raymond Gardella (1911–1971), son of John and Rosa. They had four children: Marilyn, Jean, John, and Raymond. Raymond Sr. was an accountant and also a musician with his own band. After Ray's death, Nellie married Frank Gaiero.

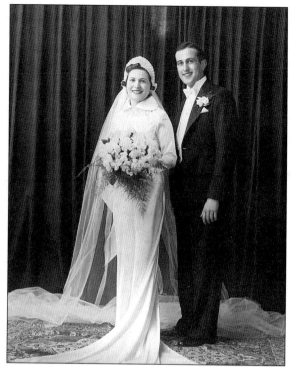

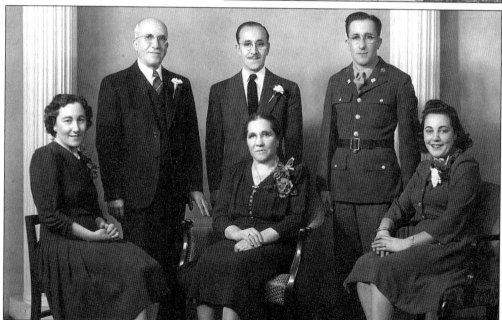

Donato and Costanza (DiGiacomo) Forte were among the large group of emigrants from the hill town of Bisegna in Abruzzi. They were married in Bisegna, and their first child, Antonina (1907–1969), was born there. From left to right are the following: (front row) Antonina/Mrs. Charles DiGiulio; Costanza (1884–1957); and Eda (born 1918), who married Edolo Lupi (see page 44); (back row) Donato (1884–1973); John (born 1911), who married Mary Coppola and Cecile Marcotte; and Vincent Forte (1913–1996), who married Elizabeth Tufo.

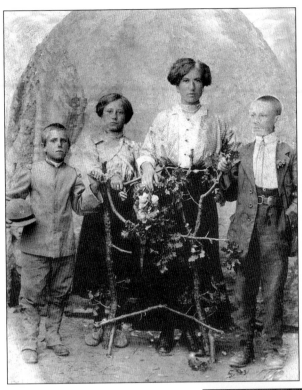

Four of the five Porro children from Aquila, Abruzzi, are shown at their Italian home. Their parents were Vittorio Porro (1860–1916) and Natalie Mecca (1868–1944). Vittorio, and his eldest son Achille/Archie (1892–1957), a barber, were the first of the family to immigrate. The rest of the family was delayed from traveling because of the devastation of the great Messina earthquake. From left to right are Alfred, Mary (1900–1995), Antonetta (1888–1964), and Tony Porro (1898–1966). Antonetta married Achille Pagnottaro (1887–1960). Their son, S.Sgt. Antonio Pagnottaro (1919–1944), was killed on the island of Corsica in 1944 during World War II.

Mary Porro (1900–1995), after immigrating to Haverhill, was a member of the first class to attend the Moody School. She married Peter Migliori (1896–1974) in 1918. Peter, like Mary, had also been born in L'Aquila, Abruzzi. They had two children, Boris (born 1922) and Natalie/Mrs. Angelo Traverso (born 1924). Peter had worked in the shoe shops and had also operated a bike rental business from his home on Hall Street. Boris continued the family connection with bicycles when he purchased H.R. Sawyer Bicyle Shop, after he completed his service with the U.S. Army Air Force in August 1945. The business is now the Schwinn Bicyclery on Ginty Boulevard.

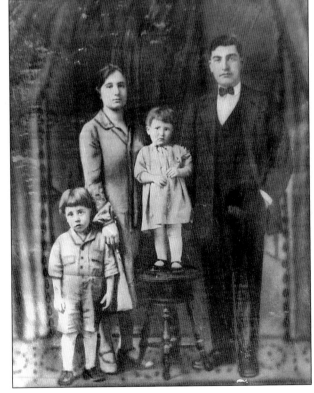

Joseph Moro (1894–1995) immigrated to Haverhill from Ortona, a town in Abruzzi on the Adriatic Coast. He was the son of Angelo, who died in Italy, and Filomena (1857–1929), who died in Haverhill. Moro was a shoe worker who never married. He lived on River Street and Bartlett Street before buying a two-family house on Blossom Street, Bradford, in 1939. In his later years, he worked at General Electric in Lynn. Moro was an excellent gardener and is shown in this picture tending to the rock garden he created behind his Bradford home.

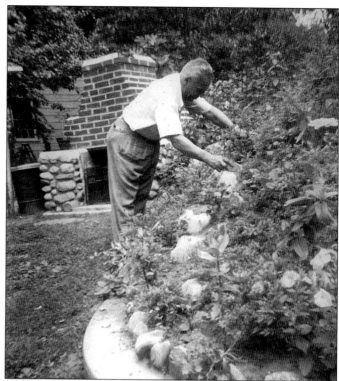

Onorina Moro, right, (1886–1971) was the sister of Joseph Moro. In 1910, she married Generoso "Jake" Grassi (1877–1964), who had also immigrated from Ortona, Abruzzi. They had five children: Maldina/Mrs. Thomas Kelly (1915–1994), Vincent (born 1916), Serafino/Sam (1917–1966), Gilda (born 1918), and Flora/Mrs. Salem Thomas (born 1925). Jake was a shoe worker and an accomplished accordionist. The Grassis shared Joe Moro's house in Bradford.

The 1910 census listed 19-year-old Frank Emilio ("Ammeleo") as a lodger in the 173 River Street home of Giacomo and Mary Nibaldo. Emilio (1885–1959) was a laster in a shoe shop and had emigrated from his Abruzzi home in 1906. He married Ida Perozzi (1890–1947), from Pescena, Abruzzi, in 1911. They had nine children: Claudia/Mrs. Dionigi DiCristofaro, Eva/Mrs.Mickey Camuso (died August 2000), Bennie, Romeo, Orazio, Louise (died in infancy), Anna/Mrs. Dominic Accardi, Alfred, and Frank Jr.

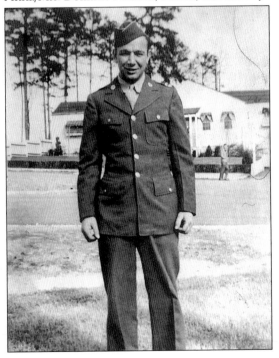

Orazio Emilio, third son of Frank and Ida, was killed in action in the World War II invasion of Southern France in 1944. He was 24 and had survived the Allied campaign in Italy. Emilio had attended Haverhill High School and worked in a shoe shop before enlisting in the service in 1942. In addition to the invasions of France and Italy, he had also fought in North Africa and had been part of the invasions of Sicily and Salerno. Other men of Italian descent who were killed in World War II were Matthew Augusta, Orfeo Bianchi, Marino Conte, Harry Delva, Sebastian DiBartolomeo, Anthony Euele, Manuel Grasso, Dominick Marinaro, Alphonse Moscaritola, Antonio Pagnottaro, Harold Santarelli, and Joseph Saviola.

Bernard "Bennie" Emilio (1915–2000), oldest son of Frank and Ida, was inducted into the army in June 1942. He fought in the South Pacific, including 27 months of jungle war. Bennie earned the Bronze Star for heroism. He was married in 1946 to Ann Minichiello, the daughter of Bernadino (1880–1968) and Rosina (1890–1989). Bennie worked in Haverhill's shoe shops but also boxed as a welterweight with a 47-5 record. A third Emilio son, Romeo, was drafted into the U.S. Army in July 1945 and served even though he was a married man with twin daughters and had lost one brother in action the previous year.

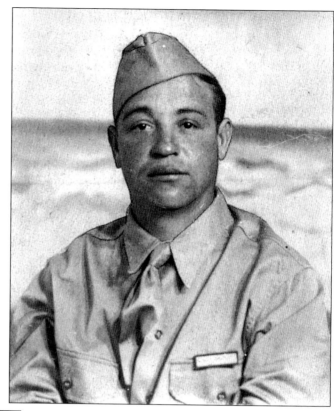

Frank Emilio Jr., youngest child of Frank and Ida, is shown here on Easter Sunday 1944 wearing a child's version of the army uniform of his brothers, Bennie, Romeo, and Orazio. He is standing in front of the family's Hall Street home. Frank, like his older brother Al, was a three-sports star in high school. He entered politics and served 11 years as a Massachusetts state representative.

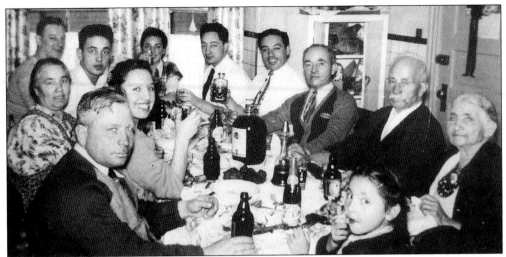

Rafaele DiVincenzo, second from right, had a roundabout migration from his home in San Sebastiano, Bisegna, Abruzzi. He was in the army during the Italian-Austrian war. He and his family went to Sao Paolo, Brazil, with other Italians to work in the coffee plantations. He moved with his family to River Street, Haverhill, to work in the shoe shops c. 1913. By World War II, the family was living on Laurel Avenue, Bradford, where this picture was taken. Clockwise from the bottom of the picture are Sandra (born 1940), Giuseppe (1896–1981), Leonilda DiVincenzo Herrick (born 1923), Maria (Parisse) (1901–1975), Emilio (1929–1993), Charles Howard (1920–1954) and wife Elissa DiVincenzo (1921–1999), Loreto (born 1925), Rafaele (born 1923), Giovanni (1894–1988), Rafaele (1865–1952), and Leonilda (Fallucci) DiVincenzo (1870–1951).

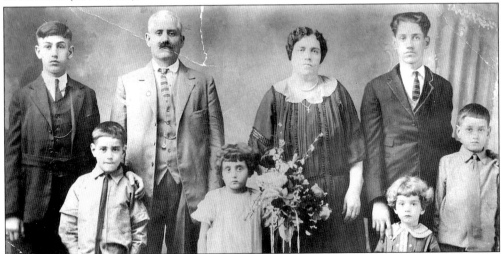

Anina Marie DiVincenzo (1920–1976), center, was one of 15 children born to Pretrangelo (1886–1963) and Angelina Grassi DiVincenzo (1886–1951). Anina and five brothers survived to adulthood. All five sons served in World War II. Pretrangelo, a stonemason, and Angelina were immigrants from San Sebastiano, Abruzzi. Anina, also known as Annie, married Louis Sapareto in 1944. They had three daughters: Lois/Mrs. Alan Fullerton, Mary Carmella/Mrs. James McCoon, and Rose Marie. From left to right are the following: (front row) Frank, Anina, Alfredo (known as "Doy"), and Sebastino/Sam; (back row) Petrache/Pat, Petrangelo, Angelina, and Lewis.

Amedeo Campana, the son of Domenic and Julianna (D'Addezzio), was born in Scanno, L'Aquila, Abruzzi, in 1884. He and his father immigrated in 1901. His brother Ilario/Hilary also immigrated. Amedeo married Elvira Altieri in 1911. They had seven children: Vera Mae (1914–1969), Juliana (born 1916), Iris (born 1919), Edgar (1921–1981), Eleanora (born 1923), Donald (born 1926), and Norman (born 1930). When the children were young, the family moved to the sparsely settled Bradley's Brook area. Though Amedeo was employed as a shoe worker, his avocations were gardening and music. He was a violinist, and each Sunday he performed with string ensembles at his home. Amedeo died in 1957.

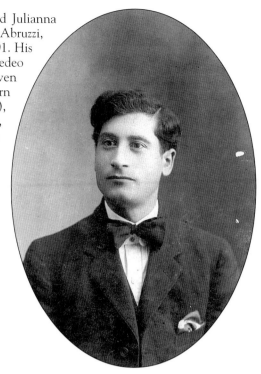

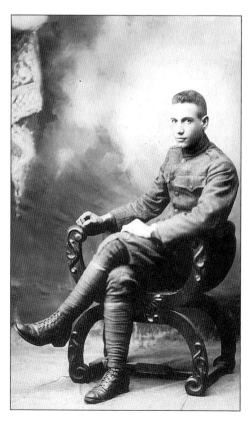

Ilario/Hilary Campana (1896–1990), the brother of Amedeo, served in the U.S. Army of his adopted America during World War I. He married Philomena Pascucci (1901–1969), the daughter of Gaetano and Inez Pascucci (see page 77) in 1923. The Pascuccis had also moved out to the Bradley's Brook area. Hilary and Philomena had two children: Domenic (1927–1960) and Barbara/Mrs. Roland Noury (born 1931). Hilary was the groundskeeper for the Haverhill Stadium for many years.

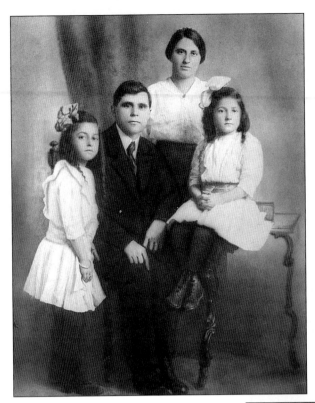

Ludovico and Carolina (Spacone) Fronterotta, like the Campana brothers, were born in Scanno. Ludovico (1882–1943) married Carolina Spacone (1890–1976) in 1908. They are shown in this c. 1915 photograph with their first two children: Mary (born 1909) and Angelina (1911–1978). Two children were born later: Anita/Mrs. Frank Barberio (1918–1994) and Anthony (born 1927). Mary married Michael Ebba and had two children: Carolyn, who married Leo Carbone, and Michael, who married Cheryl Carter. Angelina married Anthony Scalese, and they had three children: Phyliss, Anthony, and Louis.

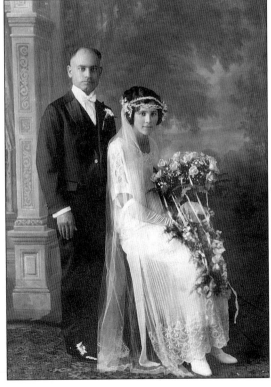

Joseph and Lucy Forte D'Orazio are shown in their wedding picture. They married on July 26, 1924, when Lucy was 19. Both were from Bisegna. The D'Orazios lived on Varnum Street and had two children, Josephine and Donato. Joseph (1895–1935) died of a cerebral hemorrhage. After Joseph's death, Lucy (1905–1995) and her two children lived with Lucy's sister and husband: Mariana and Domenick DiCristofaro. Donato D'Orazio married Romilda Zamarchi (see page 35). Josephine married Gaetano Comei.

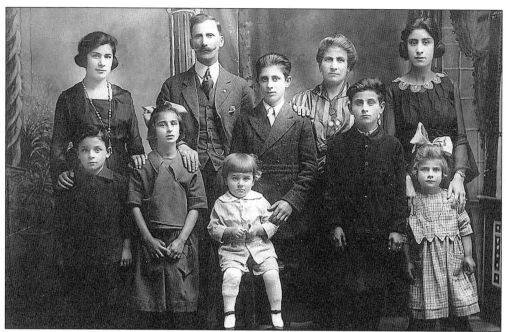

Another Bisegna family was that of Florindo (1875–1942) and Antonina D'Arcangelo (1878–1933) Villanucci. Antonina/Antoinette was the sister of John D'Arcangelo (see page 60). Florindo, who immigrated in 1905, worked in the local shoe shops. Antoinette came a few years later with their first three children. From left to right are the following: (front row) Eraldo (1914–1942); Leonda (born 1911); Arnold (1918–1995), who married Louise Carrabs; Peter (1906–1978); Jesse (1909–1997), who married Florette Gregoire; and Rita (born 1916), who married John Tatian; (back row) Betulia (born 1905), who married Ferminia Pecci; Florindo; Antoinette; and Linda (1901–1980), who married Celeste Eramo.

Carmine DiBartolomeo (1886–1962) and Anatolia DiMattia (1891–1958) were born in the village of San Sebastiano. They married in the nearby town of Bisegna in 1911. Their son Antonio was born in 1912, the year Carmine sailed on the SS *Canopic* for America. Anatolia and Antonio (1912–1974) arrived in 1914. Nine more children were born: Orlando (1915–1934), Domenica Mary (born 1917), Paladino/William (1919–1961), Alfred (1921–1998), Philomena (born 1923), Ernest (1925–1981), Arthur (1927–1996), Vittorio/Pete (born 1929), and Luigi (born 1931). Carmine worked in a River Street shoe shop near his Varnum Street home. He was a foreman in the cutting room. Anatolia was a homemaker noted for her cooking, especially the produce that came from Carmine's garden and grape arbor.

Geremia DiPietro (1864–1926) served in the Italian army in Morocco in late 19th century. At his home in Bisegna, Abruzzi, he had extensive wheat fields and in winter engaged in long-distance trade in animal hides. He even served as mayor of the town of Bisegna, but DiPetro wanted to go to America. Genoveffa DiGiacomo DiPietro, his wife, was reluctant to leave because her family was established and had a number of businesses in the town. She did, however, have a sister and husband in Haverhill, John and Demetria D'Arcangelo, and it was with them that DiPetro stayed until he could persuade his family to join him.

Genoveffa DiGiacomo DiPietro (1876–1963), left, wife of Geremia, is shown with two of the first DiPietro children in Bisegna. Leo (1907–1984) is in the center and Victoria/Mrs. Michael Rossetti (1894–1960) is standing on the right. Three other children were born between Victoria and Leo, all of whom died of pneumonia.

Samuele Conte was also waiting for the DiPietro family to arrive in Haverhill. He was engaged to marry Victoria DiPietro and sent her this picture postcard from "Evrlmasso" (Haverhill, Massachusetts) in December 1914. He addressed Victoria as his "cara sposa." Samuele and his brothers Raphael and John had immigrated in 1897. He was 15 years old in 1900 when the census taker found the Conte brothers living in a boardinghouse run by Rosate and Erminia Forte that was a home to many other young men from Bisegna. He worked as a bootblack at the Hotel Whittier. Samuele Conte never did marry his cara sposa. He died in August 1916, a few months before the DiPietros came to Haverhill.

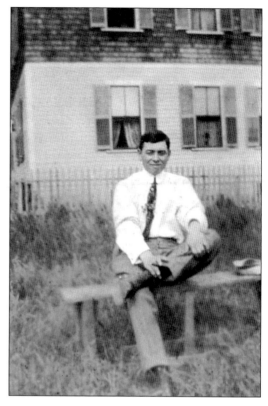

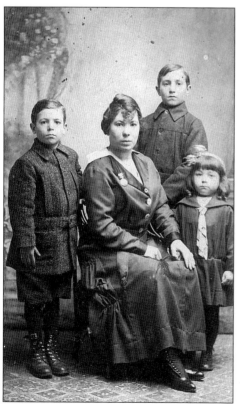

Geremia DiPietro made repeated trips to Bisegna to persuade his wife to join him. Two more children were born: Daniel (1909–1986) and Dena (born 1913). It took an earthquake in 1916 to finally convince Genoveffa to leave. The family sailed from Naples, except for Victoria, who had contracted an eye disease while the family was being sheltered in a French-owned lumbermill in Bisegna. German submarines made the voyage dangerous. Genoveffa DiPietro was pregnant with her last child, Medina (born 1917), and she and young Dena were allowed to sleep in the ship's infirmary during the trip. Victoria sailed, finally, when World War I ended—just before new immigration laws put a halt to Italian immigration. From left to right are Daniel, Victoria, Leo, and Dena DiPietro.

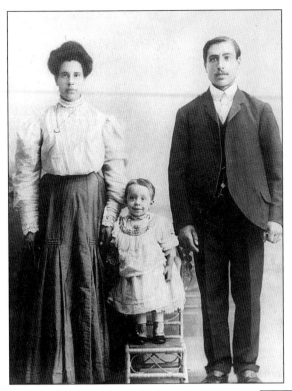

Pasquale Grieco (1882–1967) and Irene Bochichio (1883–1932), from Abruzzi, immigrated in 1902 and were married in 1905. Patsy Grieco became a plumber and Irene worked at the Stevens textile mill. The family home was at 36 Grove Street. They are shown with their first child, daughter Rose/Mrs. Andrew Insero (1906–1993). Other children included Annie/Mrs. Rocco Zito (1908–1993), Frank (1910–2001), Josephine/Mrs. Edward Beaudoin (1912–1978), Louis (1916), and Alice/Mrs. Francis Behan (1918–1997).

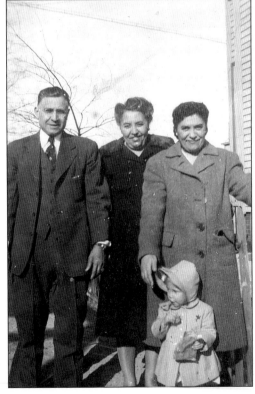

Albina Carapucci (1898–1989), center, and her sisters Christine (1901–1975) and Sue came with their mother, Maria, from Abruzzi c. 1909. They were to be reunited with their father. He, in the meantime, had gone to Ohio to seek work, and no word was ever heard from him again. It was assumed he died in Ohio. Albina had to go to work in a hat shop while still very young. In 1915, she married Quirino DiProfio (see page 78). Christine, right, married Generosa (Jerry) Piccirillo, left, in 1923. Jerry (1896–1966), who was born in Italy, worked as a top lifter in the shoe industry. The Piccirillos had four children: Lucy, Mary Ann, Niblo, and Rita. Also in the picture is Lucille DiProfio, Albina's granddaughter.

Domenico Forte (1883–1962), right, and his wife, Lucia DelGrosso (1889–1979), also claimed Bisegna as their birthplace. They married in Italy in 1906, the same year Forte came to Haverhill. Lucia followed two years later. Forte was a janitor whose last place of work was Western Electric. Lucy worked in local shoe shops. There were five Forte children: Jenny (born *c*. 1910), Michael (born *c*. 1911), George (born *c*. 1913), and twins Frank and Tony (born 1918). Lucy (below, back left) is shown with her son Frank (seated front) and with Hilda Brandolini, future wife of her son Tony. Tony was in military service when this 1942 picture was taken. Standing next to Lucy is Hilda's mother, Augustina/Mrs. Alfred Brandolini.

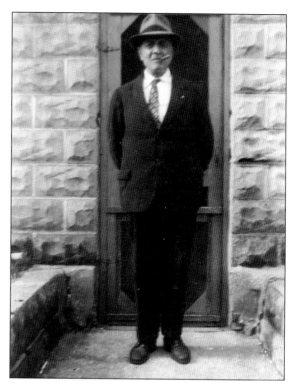

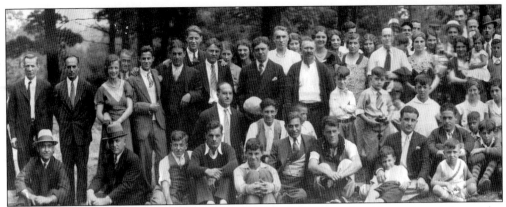

The Bisegna reunion is shown in this sequence of four photographs. Above, from left to right, are the following: (first row) Dom DiCristofaro; Angelo Ventura; Parky D'Arcangelo; two unidentified; Michael Buccini; two unidentified; ? Villanucci; unidentified; Dan DiPietro; Pat Angelotti; and Vinnie Morelli; (second row) Dom DiPietro; Peter Villanucci; and Rudy Conte; (third row) Sebastiano Basile; Liberio Subrizio; Madeline D'Arcangelo; P. D'Arcangelo; Dom DiGiulio; unidentified; Billy D'Arcangelo; Joe, Virginia, and Anita Conte; Felix Leone; Tony Liberati; Liberato Forte; Aris DiPirro; John Russo; unidentified; George Basile; Nina Forte; and Florence Eramo; (fourth row) Vera D'Arcangelo (behind Liberato Forte); Ida Conte; two unidentified; Agnes D'Arcangelo; Graziano and Anina DiPirro; two unidentified women with babies; and Guy Comei. In the fifth row on the far right are Mr. Leone and Frank Comei.

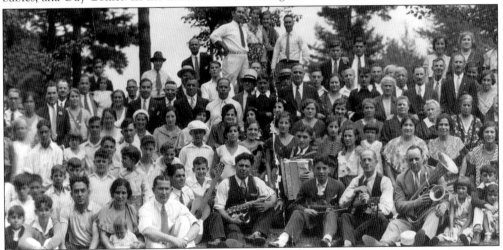

From left to right are the following: (first row) unidentified, Ray and Liberio Basile, Mary and Achille Forte with baby, Patsy Angelotti (guitar), Arnold Villanucci, Louis Angelotti (saxophone), Elmo Buccini (violin), two unidentified, Alice Villetta, John DiPirro, and Lillian Villetta; (second row) two unidentified, Joe DiGiulio, unidentified, Armand Grassi, three unidentified, Ludovico and Helen DiGiulio, unidentified, Ann DiGiulio, Maurice Angelotti (accordion), Rose DiGiulio, ? Buccini, unidentified, Modestina DiGiacomo, Ann and Mary Basile; (third row) Yolanda Comei, Tony DiCristofaro, four unidentified, ? Villetta, two unidentified, Lucy DiGiulio (in dark beret), Leonda Villanucci, Philly Comei, Jennie Forte, Rita and Antoinette Villanucci, two unidentified, and ? DiGiulio; (fourth row) Dom and Lucy Comei, four unidentified, Lucy D'Arcangelo, Jennie Bologna, 10 unidentified, Dominic Forte (behind accordion player), unidentified, Lucy Forte, P. D'Arcangelo, ? Villanucci, two unidentified, Florindo Villanucci, three unidentified, and Antonia DiGiulio.

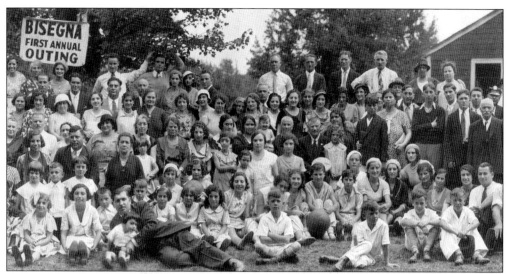

From left to right are the following: (first row) Ida Morelli; unidentified; Frank Conte; ? Morelli and son Buddy; unidentified; June Bologna; Nancy DiGiulio; Mary Basile; Mary Grassi; two unidentified; Theresa Villetta; three unidentified; Dena Coppola; four unidentified; ? D'Arcangelo; Betulia and Linda Villanucci; and Marlo D'Arcangelo; (second row) Alba D'Arcangelo; Donato and Josephine D'Orazio; Yoland DiPirro; Jennie Villetta; Norma, Clara and Condina DiGiulio; and Ann DiPietro; (third row) Antoinette and John Basile; Mary Forte; and Estelle Pecci (little girl); (fourth row) two unidentified; Marion D'Orazio; two unidentified; ? DiPietro; Rose DiPirro; Mary DelGrosso; unidentified; Domenica and baby Edna DiPietro; and Liberato and Domenic Forte; (fifth row) Rose Comei; unidentified; Suzie Cox; Eleanor Mugavero; unidentified; Lucy Forte; seven unidentified; Philly DiPirro (in dark dress); four unidentified; Mario Buccini; Theresa and John Buccini and son; Mario DelGrosso; Tony DiPietro; and John Leone; (sixth row) Sam Comei; unidentified; and Rocco Forte; (seventh row) eight unidentified and Tony Pecci.

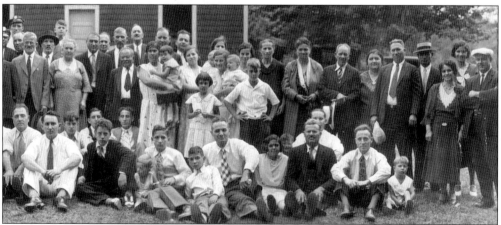

From left to right are the following: (front row) Luciano Conte; ? Forte; two unidentified; Sam Buccini (in dark suit); Domenic DiGiulio; an unidentified baby; and Clinton, Dominic, Liberio, and Edo DiPietro; (middle row) John and Adamo D'Arcangelo; unidentified; Donato DiPietro; and Antonio Buccini (short man); (back row) seven unidentified; Massimino Basile (behind Antonio Buccini); seven unidentified; Mary and Nick DiGiulio (holding light cap); Joseph D'Orazio (wearing straw boater); and Lucy D'Orazio (Joseph's wife).

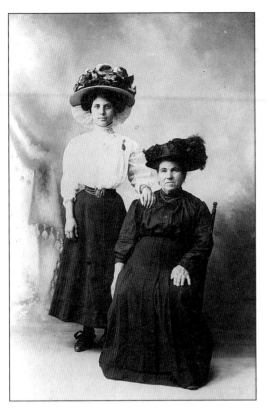

Christine Colarusso (1894–1977), left, and her mother, Maria Joanna Colarusso, were from Campobasso, Molise. Christine was the youngest of the Colarusso/Ross children. The other children were sons Daniel and Tony and daughters Rose/Mrs. James Bucuzzo, Annie/Mrs. Vittorio Mangione, Lucy, Margaret, Susie, and Christine. Tony (1875–1952) changed the family name to Ross when he went into the construction business. This photograph is from the first decade of 20th century, when such large hats were in fashion and before Christine married Frank Fruci. After Frank's death, she married Ignazio Palermo.

The province of Molise is immediately south of Abruzzi in eastern Italy. Its capital city, Campobasso, was the home for Vittorio Mangione (1876–1950) and Anna Colarusso/Ross (1883–1978). Their families had known each other in Italy; however, Vittorio and Anna met and married in Haverhill. When Vittorio first came to America, he worked in the mines in West Virginia. Next he lived in Providence, Rhode Island, before making his final move to Haverhill. He married Annie c. 1904 in St. James Church. They had nine children: Rose/"Susie" (born 1905), Jennie/Sr. Costanza (born 1906), Daniel (1908–1958), Michael (1910–1964), Helen/Mrs. Hector Beaulieu (1913–1960), Henry (1915–1979), John (born 1917), Louise/"Kelly" (born 1919), and Dorothy/Mrs. Peter Davoli (1920–1976).

Three
NAPLES AND VICINITY

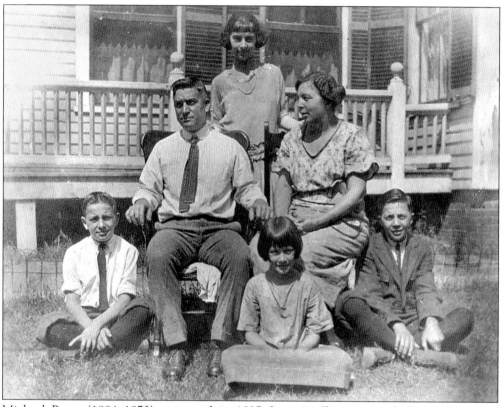

Michael Basso (1884–1970) emigrated in 1897 from Avellino, west of Naples. He was a naturalized citizen by 1910. Michael married Lena Bucuzzo (1883–1964), who immigrated in 1897 from Grottominarda. She was the daughter of Michaelangelo and Mary Bucuzzo. Her parents, her brothers Joseph and Gennaro, and her sister Concetta Lanza all came to Haverhill. Michael Basso's occupation was a heel burnisher in the local shoe shops. The family lived on Washington Street and later on Jackson Street. From left to right are the following: (front row) Carmen (1912–1997), who married Edith Fantini; Pauline/Mrs. John Medaglia (1914–1988); and Anthony (1909–1975), who married Florence West; (middle row) Michael and Lena (Bucuzzo) Basso; (back row) Mary/Mrs. Armand Hamel (1907–1994).

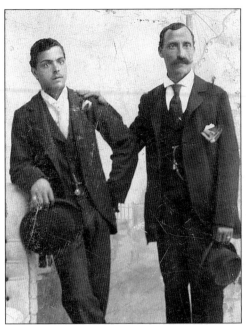

Michaelangelo Bucuzzo was born in Grottaminarda, Campania, in 1850. The town is immediately west of the Abruzzi border. Bucuzzo and wife Maria, who was also born in 1850, immigrated in 1887 a few years in advance of his sons Joseph and Gennaro and his daughters Lena Basso and Concetta Lanza. He had married in 1868. By 1910, he was a naturalized citizen and operated a grocery store. Maria died in 1934. Bucuzzo's son Gennaro is on the left in the photograph. Michaelangelo, on the right, died at the age of 103 in 1953.

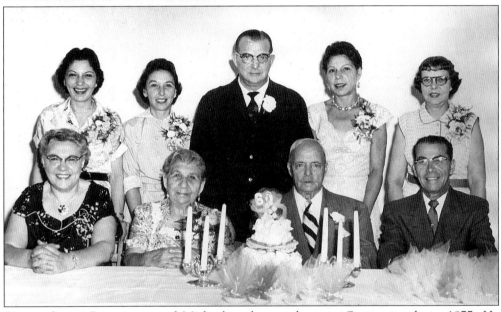

Gennaro/James Bucuzzo, son of Michaelangelo, was born in Grottaminarda in 1877. He immigrated to Haverhill in 1891 and married Rosa Ross (see page 66) in 1896. Rosa was born in Campobasso, Molise, in 1874 and immigrated in 1896, the year she married. They had 10 children. Two died young and their first son, Michael, was killed in World War I. Michael was the first Italo-American to die in the war and the Michael Bucuzzo Post, Italian-American War Veterans, honors his memory. This picture was taken at the 60th anniversary of James and Rose in 1956. They are shown with their seven surviving children. From left to right are the following: (front row) Mary/Mrs. Michael Gambino, Rose, James, and Patrick; (back row) Anna/Mrs. Nino Paltrinieri, Susie/Mrs. John Morelli, Rocco, Jennie/Mrs. Joseph Signorelli, and Lena/Mrs. Gerald Collins.

Rose Bucuzzo and other Gold Star mothers were taken to Europe in 1934 by the American government to pay respects at their sons' graves. Rose is kneeling in prayer at her son Michael's grave in Flanders Field. Other men with Haverhill connections who died in World War I were Pasquale Barrasso, John Bassani, Pasquale Gullo, James LoConte, F. Bruno Marinaro, and Michael Usuriello—who were with the American forces. Michele Giangregorio and Giuseppe Lucci of Haverhill were killed while fighting as volunteers with the Italian army.

Michaelangelo Bucuzzo lived to be 103 years old. He died in 1953. The year before his death, he posed for the photographer in this five-generation picture of his family. From left to right are the following: (front row) Michaelangelo holding his great-great-grandson Joseph Bevilacqua; (back row) Shirley Signorelli Bevilacqua (great-granddaughter), James Bucuzzo (son), and Jennie Bucuzzo Signorelli (granddaughter).

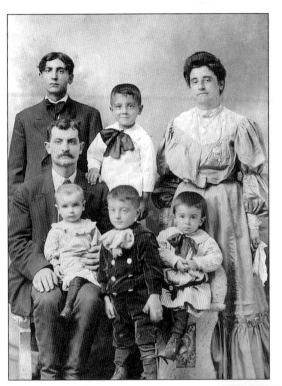

Rocco Basso (1875–1961) was born in Grottaminarda. He came to Haverhill in 1897 and worked as a shoemaker. His wife was Annunziata Villanova (1880–1958). She immigrated in 1900 and was accompanied on her voyage across the Atlantic by Bernardino Minichiello (see page 126). Rocco and Annunziata were married in 1900. From left to right are the following: (front row) Rocco holding Thomas (1906–1992), Michael (1902–1945), and Nicholas (1904–1990); (back row) Anthony Villanova (1891–1912), Louis (1901–1973), and Annunziata. Later children were Josephine/Mrs. Vincent Romatelli (1908–1983), Anthony (1910–1985), and Henry (1913–1951). Michael is shown wearing the boots handmade by his father to compensate for a leg injured in a fall.

Michael A. Basso, the second son of Rocco and Annunziata, married Iris Bachini (1909–1944) c. 1928. Iris was the daughter of Giulio and Ferdinanda Conforti Bachini (see page 40). Their attendants, in the back row, were Iris's sister Carlotta/Mrs. Charles Kershaw and Michael's brother Thomas Basso. Michael and Iris had two sons, Robert and Michael. Basso was an incorporator and first manager of the Haverhill Italian American Credit Union.

Michael (1861–1950) and Teresa Moscaritolo (1870–1953) immigrated from Grottaminarda in 1909 with two daughters. Lucia (1889–1968) married Michaelangelo Palumbo. Adeline (1898–1997) worked as a weaver in the textile mill and as a shoe worker. Their father, Michael, was a shoe worker. The Moscaritolos and the Palumbos shared a home at 1 Baldwin Street. Michael is shown with his granddaughter Mary Palumbo (1911–1983), who sits in an elaborate baby stroller.

Moscaritolos and Palumbos pose in this c. 1913 photograph. From left to right are the following: (front row) Adeline Moscaritolo and Lucia Moscaritolo Palumbo with baby Mary; (back row) Pasquale and Michaelangelo Palumbo. The Palumbo brothers were the two youngest sons of Antonio Palumbo (1856–1927), who lived in Haverhill for 30 years. Michael Palumbo (1886–1953) worked as a bottler, a grocer, and a shoe worker. He and Lucia had five children: Mary, Antonio, Michael, Theresa, and Yolande.

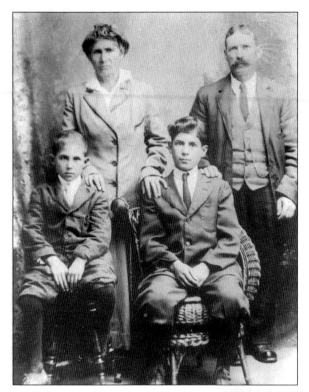

Giovanni Penta (1863–1955) and his wife, Maria Moscaritolo (1875–1937), were from Grottaminarda. They were married in Italy and had their six children there. The Pentas had four sons (Pasquale, Thomas, Michael, and Henry) and two daughters (Antoinette DeLeo Schena and Mary/Mrs. Ludovico Iafalla). Giovanni, also known as John, came to Haverhill in 1901 and Maria in 1907. From left to right are the following: (front row) the two youngest sons Henry and Michael Penta; (back row) Maria and Giovanni.

Ludovico Iafalla (1887–1966) arrived in Haverhill in 1904 from Abruzzi. He was 17. His wife, Carmella (known as Mary), was the younger daughter of Giovanni and Marie Penta. She was born in 1899, just before her father left for America. The Iafallas were married in 1915. Ludovico was a mason and a blacksmith. He and Mary were the parents of Sinabaldi/Gary (1916–1966), Josephine, and Albert/"Chuck." Mary Penta Iafalla died in 1985. She had lived in Haverhill over 75 years.

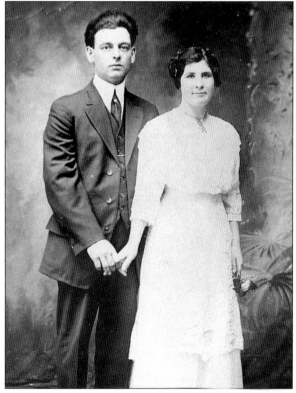

Antoinette Penta (1888–1975), the daughter of Giovanni and Maria, emigrated in 1904 from Grottaminarda. She married Lorenzo DeLeo in 1907. Lorenzo (1873–1919) was also from Grottaminarda. He had become a naturalized citizen in 1902, suggesting that he must have immigrated in the 1890s. Lorenzo was a shoemaker who later had a grocery store at 84 River Street. The DeLeos had one son, Nicholas (1913–1987). Lorenzo died during the Spanish influenza epidemic at the end of World War I.

Four years after the death of her husband, Lorenzo, Antoinette Penta DeLeo married Rocco Schena (1887–1976). Rocco was also from Grottaminarda. He worked in the Haverhill shoe shops. The Schenas had four children. The family is shown at their 9 View Street home. From left to right are Victor (1926–1983), Gloria (born 1930), John (born 1924), Antoinette, Fiore (born 1928), and Rocco.

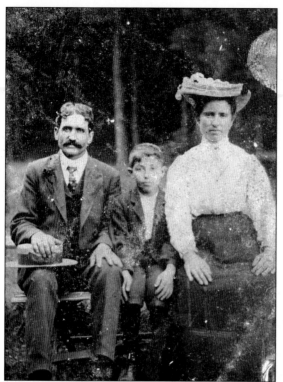

Rocco Sapareto, born Rocco Scoppetuolo in Grottaminarda (1869–1949), married Mary Carmella LaManna (1866–1953) c. 1887. They had two sons born in Italy: Francesco/Frank and Luigi/Louis. Rocco immigrated in 1891 and intended his wife and sons to follow, but an unscrupulous relative kept the money sent for their passage. The family arrived in Boston finally in 1900, but the wife's inability to speak English while attempting to explain to immigration officials that she was "separate" from her husband, ended up with their name being entered as "Sapareto," and so it remained. Rocco was a shoe worker, had his own shoe-shine parlor, and was a bottler for which he joined the United Brewery Workmen of America union. The family still has his union dues book. Rocco and Mary Carmella are shown c. 1905 with her nephew Michael Senito.

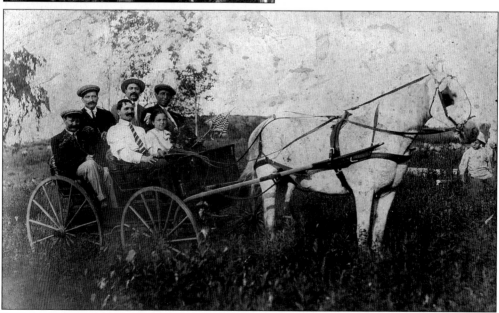

Rocco and Mary Carmella Sapareto had two American-born daughters, Marie Antoinette (1906–1994) and Anastasia Victoria (1908–1985). On a lovely summer's day, Rocco hitched up his horse, White Nellie, to his Democrat wagon and took the girls and some friends to an Italian lodge picnic in Ward Hill, Bradford. Rocco and M. Antoinette are in the front seat. In the back are, from left to right, Joseph Mazzola, Dominic Renda, Dominick Marinaro, and Frank Renda. On the far right is Victoria Sapareto.

Frank Sapareto (1888–1976), left, and his brother Louis (1890–1971)—who immigrated with their mother in 1900—stand beside their uncle Antonio Sapareto. Frank had his own house-painting business. Louis owned and operated the Concord Heel Company on Phoenix Row. He was in business for 40 years until the final collapse of the shoe industry in Haverhill c. 1968.

Alice Fareta (1896–1941) was the daughter of Rocco (1869–1924) and Carmela Fareta (1869–1919). They all immigrated in 1904. Alice married Louis Sapareto, above, and they had four children: Rocco (1917–1986), Frank (born 1919), Louis Jr. (1921–1924), and Rita/Mrs. Donald Funi (born 1925). Young Louis was killed in an accident by an ice wagon near his home on South Spring Street, Bradford. Louis's brother Frank married Amalia "Mollie" Ruocco (see page 81) They had no children.

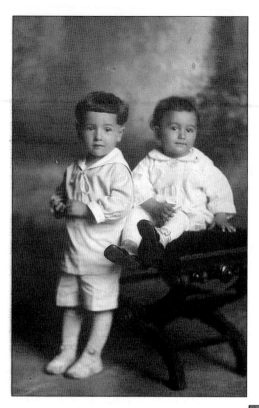

Frank and Louis Sapareto built a duplex home in 1915 in the Wood School neighborhood at 4–6 South Spring Street, Bradford. Louis and Alice's first son, Rocco (1917–1986), was born on the kitchen table in this house in 1917. Rocco became a medical doctor. Rocco is on the left and his younger brother Frank (born 1919) is seated on the right. Frank went to Tufts University and earned a degree in chemical engineering. He was a co-owner of the Concord Heel Company and, later, a teacher.

Pasquale LoConte (1895–1960), from Grottaminarda, came to Haverhill in 1916 to join his brother Ciriaco (1887–1975). He married Olympia Marciano (1908–1990), from Anzano, Avellino, in 1932. She and her parents, Carmine and Teresa (Coppola) Marciano, had settled in Topsfield. The LoContes had two children: Concetta/Mrs. Robert Brown (born 1933) and Carmine (born 1935), named for his two grandfathers. Carmine, who married Mary Janowski, was a longtime activist and leader in the Victor Emanuel Lodge, Sons of Italy. His mother, Olympia, was a mainstay at St. Rita's Church. She opened and closed the church building each day, cooked for parish dinners, provided clothing and food to the needy, and had a "telephone ministry" to shut-ins and those in need of comfort. In this wedding picture are, from left to right, Eupilo Marciano (Olympia's brother), Pasquale and Olympia LoConte, and Concetta LoConte (Pasquale's niece).

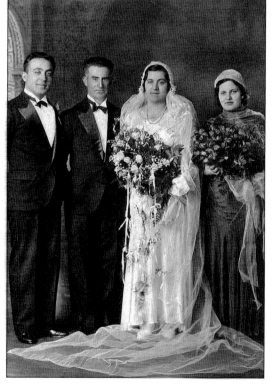

Gaetano Pascucci (1874–1948) came from Grottaminarda in 1891. His wife, Inesia Petrillo (1884–1937), daughter of Giacento and Cecilia Petrillo, came from the same area in 1896. They were married in 1897 and, over the next 20 years, had 12 children. This picture was taken c. 1905, when Rocco was an infant. From left to right are Antonio (1899–1969), Gaetano, Joseph (1903–1983), Rocco (1905–1924) sleeping in the chair, Philomena (1901–1969), and Inez. Other children were Michael (born c. 1907), Flora (born c. 1909), John (born c. 1911), Cecilia (born c. 1913), Elizabeth (born c. 1917), Eva (born c. 1918), Gloria (born c. 1924), and Grace (born c. 1925).

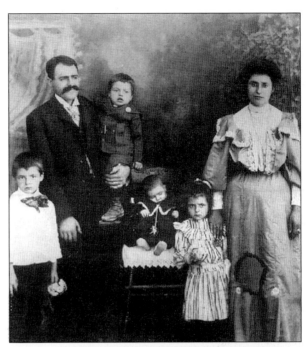

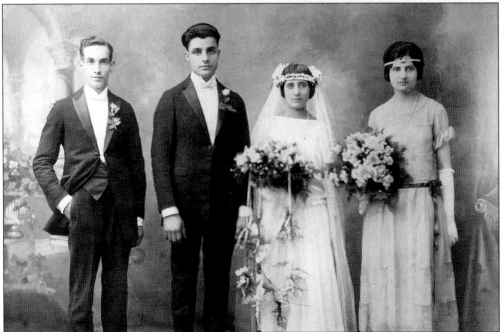

Antonio Pascucci, oldest child of Gaetano and Inez Pascucci, was married to Conda Lauretta (1906–1999) on June 29, 1924. She was the daughter of Corrado (1870–1923) and Francesca Lauretta (1876–1950). The attendants for Antonio and Conda were Ilario/Hilary Campana and wife Philomena Pascucci Campana, Antonio's sister. The Campanas and Pascuccis were among a handful of families who had moved to the western end of Haverhill by the Merrimack River in an area known as Bradley's Brook. From left to right are Hilary Campana, Antonio and Conda Pascucci, and Philomena Pascucci Campana.

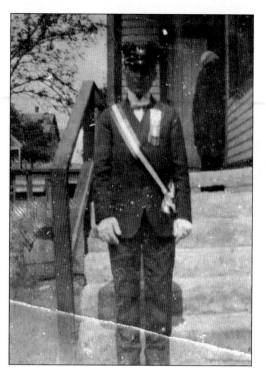

Quirino DiProfio was born in 1893. He probably came from Pescaro, Avellino, for he is discussed in a July 1930 newspaper story on Haverhill people with relatives in that earthquake-stricken area. DiProfio immigrated when he was about 19 years old, going first to Canada and then to Haverhill. He was a shoe worker until unable to work due to Parkinson's disease. DiProfio loved to sing and named his first child Melba in honor of Metropolitan Opera star Nellie Melba. He and his wife, Albina Carapucci (see page 62), had three other children in addition to Melba. Vincent (1917–1918) died of the flu when he was an infant. Vincent Joseph was born in 1919. He was a Haverhill police officer. Giselda was born in 1922. The family home was on Grove Street. DiProfio is shown as a young man in 1912 wearing the uniform and regalia of the Victor Emanuel Society.

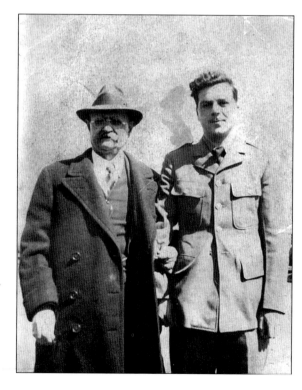

Haverhill sports fans of the World War II era remember the Capo AC and the teams it sponsored for over 25 years. The teams owed their existence to Nicola Capodelupo (1869–1960), left, who had immigrated from the Naples area in 1894. Nicola had a shoeshine store on Washington Street and was later a shoe worker. He and his wife, Michelina DeLuca (1883–1942), had 10 children: Fannie, Anna, Jennie, Malina, Josephine, John, Lenora, Nicholas, Augustina, and Paul. Capodelupo is shown in 1942 visiting his son S.Sgt. Nicholas Capodelupo Jr. (1917–1976) at his army base in Minnesota.

Carmen Danese (1869–1947), left, and his wife, Rosaria Schena (1869–1950), right, were from the Naples area. They immigrated in 1900 with their son Antonio (1895–1919). Children born in Haverhill included Delena/Mrs. Sebastian Marchisio (1901–1926), John (1902–1983), Michael (born c. 1905), and Cesaro/Charles (born c. 1907). Carmen is shown marching with the St. Anthony's Society during the St. Anthony's Festival for St. Rita's in 1943. The picture of Rosaria also dates from 1943.

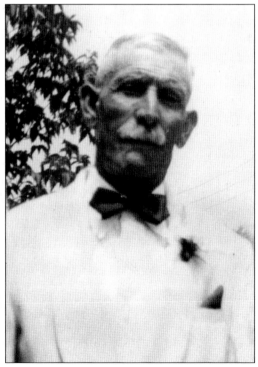

Anthony Schiavoni (1874–1951) and his wife, Conzolata Fabiano (1882–1962), were from San Sossio, Avellino. Anthony had immigrated in 1899 but returned to San Sossio to marry Conzolata in 1907. The Schiavoni children, who were all born in Haverhill, included Josephine/Mrs. Eugene Yannalfo (born 1908), Margaret/Mrs. William Ross (1909–1995), Lena/Mrs. Anthony DeFazio (1911–1962), Florence/Mrs. Carl Bavona, Patrick (1915–1976), Antoinette/Mrs. Vincent Paolino (born 1918), Philip, and John. The family lived in "the Acre," traditionally the home of the Irish and later of the Greeks. Anthony was employed as a laborer for contractors. When the 1920 census was taken, Conzolata's brother James Fabiano was living with the Schiavonis. He was 26 at the time and had immigrated in 1912.

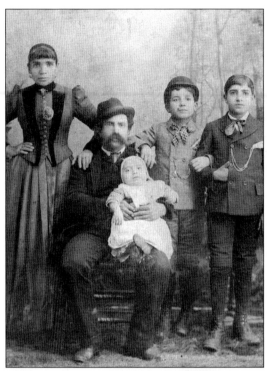

Giovanni DiTommaso (1852–1932) and his wife, Rose Pazzanese (1857–1900), from Salerno, Campania, were one of the first families from southern Italy to establish themselves in Haverhill. This photograph is dated 1893. From left to right are the following: (front row) Giovanni/John holding Joseph (1893–1945); (back row) Rose, Allesandro/Andrew (1883–1965), and Nicholas (1882–1962). Two more children were born after this picture: Anthony (1894–1965) and Jennie/Mrs. Joseph D'Orlando (1896–1966). John remarried after Rose died. His second wife was Mary Patsonasse (1851–1929). Allesandro DiTomasso, Giovanni's second son, and Allesandro's son John owned A. DiTommaso & Son Jewelry Company. Joseph was an organizer of the Michael Bucuzzo Post Italian-American World War veterans. Nicholas and Anthony were shoe workers.

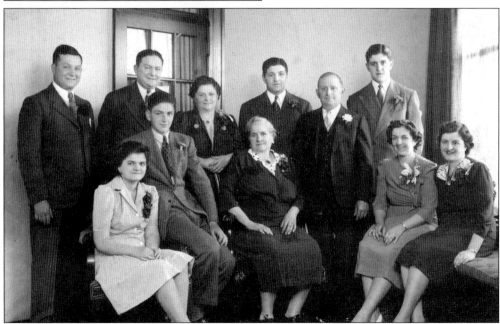

Franco D'Agosto/Augusta (1878–1945) and Emelia Romanelli (1887–1949) were married c. 1906. Frank came from Roccadaspide in 1897, and Emelia emigrated from Agropoli in 1905. Both places are south of Naples. Frank worked for the City Public Property Department. From left to right are the following: (front row) Theresa, Anthony, Amelia, Julia Medaglia, and Eda Levasseur (1914–1962); (back row) Nicholas (born c. 1912), Pasquale (1907–1967), Emanuelle Benedetti (born c. 1910), Louis (1917–1986), Franco, and Gabriel/Billy.

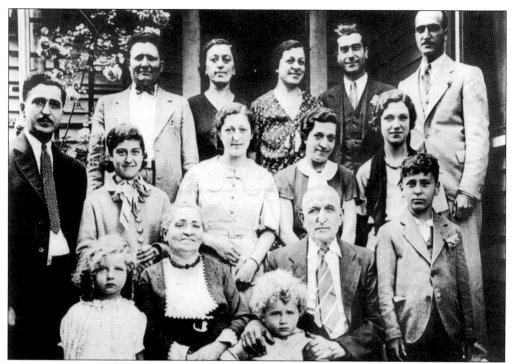

Antonio (1863–1935) and Maria Pinto (1874–1954) Ruocco were from Agropoli, a fishing village south of Salerno. They met in New York City, married, and had 10 children at their home on Coney Island. They came to Haverhill in 1909 to join Maria's brothers Pasquale and Carmine Pinto. An 11th child was born in Haverhill. From left to right are the following: (front row) Maria Ruocco, Maria Pinto Ruocco, Anthony Ruocco, Antonio Ruocco, and Joseph Pepe; (middle row) Richard Ruocco (father of Maria and Anthony), Antoinette Pepe, Mary Ruocco Fichera, Margaret Ruocco Neville, and Eunice Barrett Ruocco (wife of Richard); (back row) Frank and Mollie Ruocco Sapareto, Tillie Ruocco and Piero (Pete) Pepe, and Frank Ruocco. Missing from this picture are Vincenzo (Jimmy), Carmine (Johnny) Ruocco, and Elena Ruocco Cocozza.

Francesco (Frank) Ruocco (1900–1970) was the second son of Antonio and Maria. He studied art at the School of the Boston Museum of Fine Arts and, for six years, at the University of Rome. When he returned to Haverhill, he set up a studio on Water Street, where he specialized in stained-glass windows. His work can be found in churches and public buildings throughout the United States. Frank was at that location for over 30 years until forced out by urban renewal. Brothers Richard (1904–1986) and John (1906–1981), and, later, his daughter Patricia worked with him. Frank married Jeannette Ouellette and they had three daughters: Patricia/Mrs. William Bryant, Beatrice/Mrs. Joseph Ostopchuk, and Virginia/Mrs. Grant Hayden.

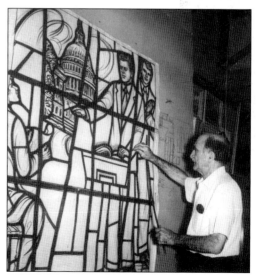

Rocco Albanese (1871–1934), who came from the Naples area, is shown at left in his Italian army uniform. Rocco married Carpanella Romandelli (1874–1949), and they both immigrated in 1896. The Albaneses had six children: Rose, Alvaria, Angelina, Leonilda, Marguerite (1907–1910), and Albert (1905–1983). Albert married Mary Montecelli. Carpanella is shown below, standing behind the family home at 56 River Street by the Merrimack River and County Bridge.

Rose Albanese/Mrs. Domenick Fulcinetti (1898–1949) and Eva Feronetti/Mrs. Frank Eramo (1899–1965) hoist Rose's sister Alvaria, who is shockingly barelegged, but well shod. The women were at Salisbury Beach. Alvaria (1899–1971), who married Domenick Montebianchi (1896–1941) in 1921, became one of the first women to accept membership into the Victor Emanuel Lodge, Sons of Italy, and the first to hold the title of venerable (president) of the Victor Emanuel Lodge.

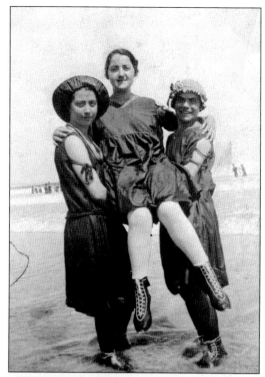

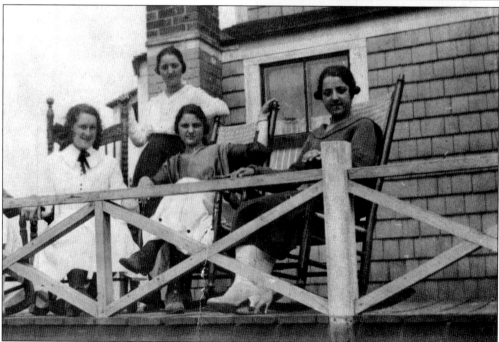

The Albanese sisters and a friend are shown at Salisbury Beach on July 4, 1919. From left to right are the following: (front row) Josephine Cook (Lakin), Leonilda Albanese/Mrs. John Zamarchi (1903–1990), and Angelina Albanese/Mrs. Lionel Lecours (1901–1969); (back row) Alvaria Albanese.

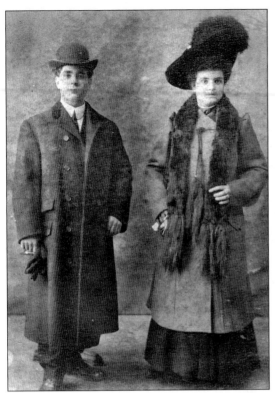

Domenico Cusano (1877–1929), from the Naples area, was the son of Arcangelo (1846–1924) and Maria Grazia (Testa) Cusano (1851–1912). He and his father arrived in America in 1891, and his mother and brother Ralph arrived in 1896. Domenico married Angelina Giuggio (1882–1972) in 1904. The Cusano family lived in a small Italian enclave amidst the French-Canadians off upper Hilldale Avenue. After Domenico died, Angelina became the second wife of John Gardella in 1931 (see page 29). Raffaele (Ralph) Cusano, below, was born in 1882. He and his brother Domenico were the only survivors of their parents' eight children. Ralph married Antoinette Savenelli, below right, who was also from the Naples area, c. 1911. Their first son, Angelo, was born in 1912.

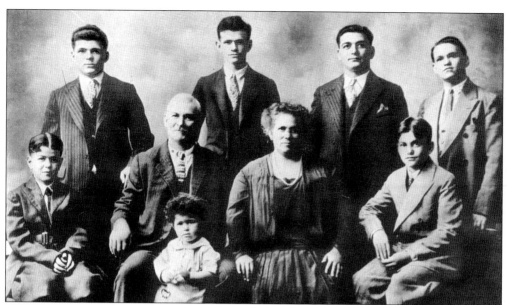

Pasquale DiBurro (1871–1949), from Naples, and his wife, Consiglia Zinno (1883–1955), from Carinola, Naples, had seven sons. The family name became synonymous with good dining in Haverhill. Pasquale, who immigrated in 1895, and Consiglia, who came in 1898, married in 1902. They lived in Haverhill on Ayer Street. The family restaurant business began when sons Giacomo/Jack and Louis opened a bar on Wingate Street for people who worked in the nearby shoe shops. Their mother would bring them sandwiches for their lunch and invariably the customers would ask to buy her sandwiches. Next, the boys asked her to make up some meatballs that the customers loved. The bar soon became the first of the DiBurro restaurants. This picture was taken c. 1923. From left to right are the following: (front row) Giovanni (1924–1967); (middle row) Luigi/Louis (1916–1976), Pasquale and Consiglia, and Giuseppe/Joe (1912–1977); (back row) Genarino/Gene (1903–1982), Loren/Warren (born 1910), Giacomo/Jack (1905–1962), and Vincenzo (1907–1983).

Frank Insero (1874–1931) and his wife, Maria (1884–1932), were from Naples. They married and immigrated in 1894. By 1910, they were living at 34 Ayer Street with their seven children: Jenny (born 1896), Andrew (1897–1932), James (1899–1965), Angelina (1902–1998), Rosie, (born 1904), Philomena (born 1905), and Joseph (born 1908). Andrew, shown on his beloved motorcycle, married Rose Grieco (see page 62) c. 1923. Andrew and Rose had two children, Irene and Frank, before Andrew's untimely death in 1932. Andrew was also a musician with his own band, the Rainbow Ramblers.

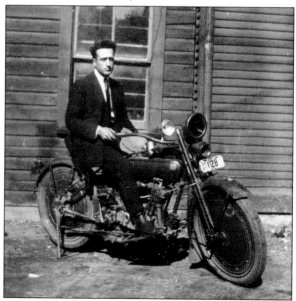

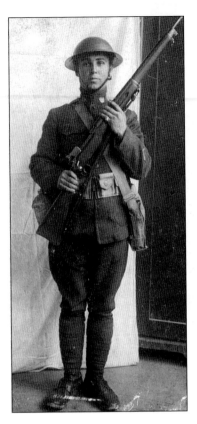

Michael N. Cardarelli (1895–1969) immigrated in 1909 from Fontagreco, Caserta, north of Naples. He served in the American army during World War I. In 1920, he married Josephine Salvucci (1898–1968), the daughter of Innocenzio (1866–1953) and Rosaria Salvucci, who had immigrated to Lawrence from Italy. The Cardarellis lived in Lawrence, where their four sons were born and moved to Haverhill in 1936. The family home was on Wilson Street and, later, at 630 River Street.

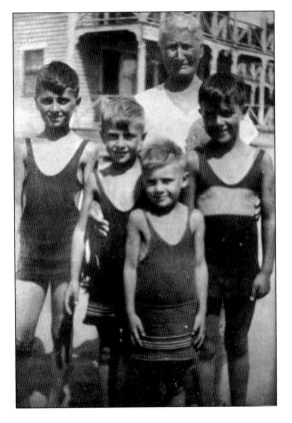

Michael and Josephine Cardarelli and family made a yearly vacation trip to Salisbury Beach. In this c. 1933 photograph, the four Cardarelli sons and their grandmother Rosaria Salvucci enjoy the sun and the sand. From left to right are John J. (born 1921), Joseph P. (born 1924), Vincent M. (born 1926), and Mario (born 1922). Standing in the back is the boys' grandmother Rosaria Salvucci (1866–1955).

Angelo Cardarelli was born in Haverhill in 1900. He was the son of Pasquale (1869–1927) and Filomena Cardarelli (1872–1939). He had four older sisters: Pasqualina/Mrs. Gennaro Spera (1897–1975), Blanche, Delia/Mrs. Joseph Marinaro (1910–1982), and Olive (1915–1925). Three infants died between 1905 and 1907. Angelo was the first person of Italian ancestry to be hired as a postal clerk and he was an incorporator of the Italian American Credit Union. His bride, Sophie Palumbo (1905–1970), immigrated at the age of 12 from her home in Albanella with her father Vincenzo (Jimmy), brother Carmine, and sister Philomena. Her mother, Maria Mucciolo, had died, and her father married Catherine Orlandella. The Palumbos lived in the Hilldale Avenue area. Angelo and Sophie had two children: Faith and David. Sophie worked for many years as a department manager for the W.T. Grant Company on Merrimack Street. Angelo died in 1985.

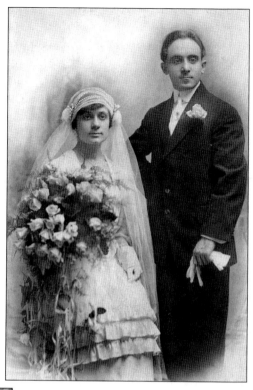

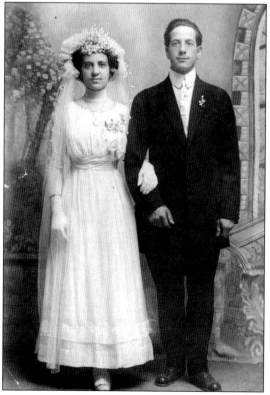

This is the wedding picture of Ferdinando Scatamacchia (1886–1970) and Concetta Carpinone (1889–1928), who were married c. 1910. Prior to the marriage, Ferdinando/Fred had been living with Leandro Nissi and family (see page 49) at 15 Maxwell Street. He had immigrated in 1898 as a young boy. Concetta was a daughter of Antonio and Domenica Carpinone (see page 89). The Scatamacchias were the parents of Hugo (1912–2001), Clara/Mrs. Adam Lesiczka, and Donald. Ferdinando's second wife, Mary, was born in 1895 and died in 1972.

Giovanni Filipe (John) Altieri (1866–1944) and Maria Sabatina Carpinone (1864–1941) were both from Fontagreca, Caserta, where they married. They came with his parents to Providence, Rhode Island, in 1887 and their daughter Elvira was born there in 1890. The young family returned for a while to Italy, where a second daughter, Erminia, was born in 1894. They were back in America in 1901 and settled in Haverhill. Two sons were born in the city: Antonio Nicholas (1903–1967) and Arthur (1905–1988). Arthur married Madeline Chaput. Altieri was a laster in a shoe factory, and his daughter Elvira was a stitcher before her marriage. Altieri, in later years, opened a grocery store at 525 River Street.

The two daughters of John and Sabatina Altieri flank Vita Perdotti from Lawrence. Vita was a family friend of Amedeo Campana from Abruzzi (see page 57), the man Elvira Altieri would marry. Standing on the left is Erminia Altieri (1893–1979), who married Pasquale Pitochelli (see page 92). Standing, right, is Elvira Altieri (1890–1984). The picture dates from c. 1909, just two years before Elvira married Amedeo.

Antonio Nicholas Altieri, the son of John and Sabatina, was born in Haverhill in 1903. During the 1930s, after being in the state police for a number of years, he was chosen to be the Haverhill city marshall, an earlier version of the chief of police. During his tenure, he was responsible for having radios installed in police cars. He then rejoined the state police and served as an aide to Gov. James M. Curley. When World War II broke out, he joined the U.S. Navy. Following the war, he worked for naval intelligence. Nick was married to Madeline Murphy. He died in 1967.

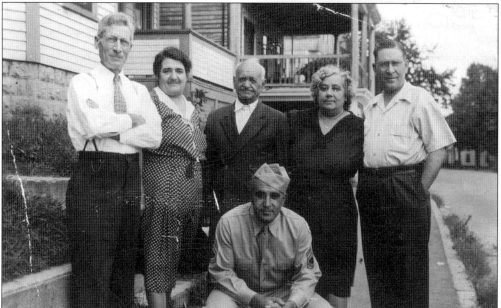

Antonio Carpinone (1864–1948), center back, was the brother of Sabatina Altieri. He and his wife, Domenica (1871–1936), married in 1887. They had seven children born in Italy. Three survived to immigrate with their parents in 1906. They were Joseph (1888–1963), Concetta (see page 87), and Amelia (1897–1950). In 1910, when the federal census was taken, the family was living at 60 River Street and two more children had been born: Antonio Jr. (1908–1959) known as "Youngie," and Alphonsina/Corabelle (1909–2001). In this 1943 photograph, Antonio Jr./Youngie is kneeling in front, Antonio Sr.'s niece Elvira and her husband, Amedeo Campana, are on the left, Antonio the elder is in the center, and his daughter Amelia and her husband, Francesco Paone, (1893–1960) are on the right.

Corabelle Carpinone DiBiaso (1910–2001) was the youngest child of Antonio and Domenica Carpinone and was born in Haverhill. She married Frank DiBiaso (1904–1985) in 1929. Frank was the son of Joseph and Mary Carma (Ross) DiBiasio. He, too, was born in Haverhill. Frank was a mason. The DiBiasios had a daughter, Carma, who married Ronald Selvaggio, son of Antonio and Maria Selvaggio (see page 103). Cora worked for years in local shoe shops. In her retirement, she was an active fundraiser for the Franciscan Mission Association. From left to right are Cora, Carma, and Frank DiBiasio.

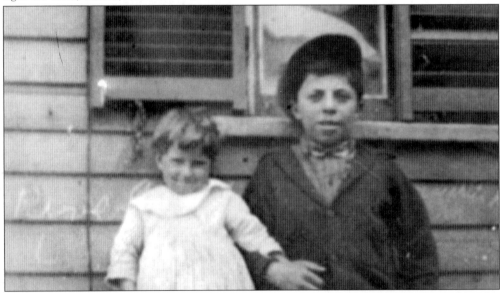

Rose and Arthur Quatrale were the children of Michael Quatrale and Gelorma Capozzoli, who had emigrated from Avellino. Rose, left, was born a year later than Arthur, who was born in 1914. The picture dates from c. 1917. Arthur married Lila Williams and had three children: Arthur Jr., Donald, and Gerald. He was a shoe worker and died in 1967. Rose married William Brigham and had three children: William Jr., Richard, and Joyce. Their son Bill Brigham Jr. was an active and integral member of the Victor Emanuel Lodge and of its Drum Corps. Rose died in 1983.

Nicholas Tuccolo (1876–1959) was the son of Antonio (1848–1912) and Philomena (1849–1931), and they had all immigrated, along with Nicholas's brother James (1882–1962), in the 1890s from Albana near Naples. When the 1910 census was taken, they were all living at 197 River Street along with Nicholas's wife, Maria Giuggio (1888–1948). Maria had immigrated in 1900 and married Nicholas three years later. Their children were Antonio (1904–1929), Filomena "Fannie"/Mrs. Gino Brandolini (1905–1992), Louisa/Mrs. Joseph Zamarchi (1907–2000), Anna/Mrs. Vincent Scizutelli (born 1909), James A. (1910–1981) Joseph (born 1913), and Domenico (born 1916). Also living with the family was Luigia Giuggio (1856–1938). Nicholas's mother, "Fannie" Tuccolo, was listed as a widow, aged 74, in the 1920 census and residing in a separate apartment in the Tuccolo house.

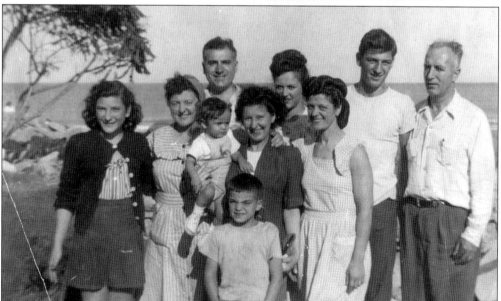

The three Tuccolo sisters gathered with their families at York Beach, Maine, on a summer's day in 1947. From left to right are the following: (front row) James Scizutelli, (middle row) Joan Scizutelli, Anna Tuccolo Scizutelli, Richard Lebro held by his great-aunt Louise Tuccolo Zamarchi, and Fannie Tuccolo Brandolini; (back row) Vincent Scizutelli, Jean Brandolini Lebro, Richard Brandolini, and Gino Brandolini (1903–1995). Brandolini was from Santarcangelo, Rimini. He was a shoe manufacturer in Haverhill and active in the Sons of Italy, the Garibaldi Club, and local politics.

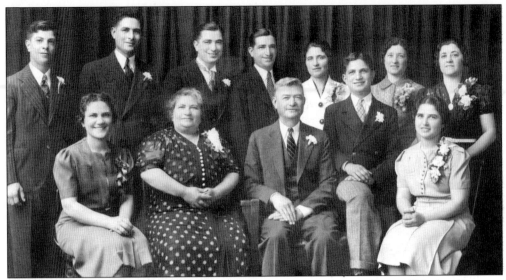

Vincenzo Bevilacqua was born in 1868 in Apice, Benevento. Apice is west of Naples. He came to America in 1898 and had received his papers for naturalization by 1910. He was a laster in the shoe industry and became the foreman for the Greenstein Shoe Company. His wife, Pepina (Maria) Simonello, born in Italy in 1884, immigrated in 1896 with her parents, Michael and Annie Simonello, and family. She married Vincenzo in 1902. They are shown with their 10 surviving children at son Michael's wedding in 1938. From left to right are the following: (front row) Josephine Papa, Maria, Vincenzo, Francis, and Angelina; (back row) Louis, Dominic/Danny, Michael, Sebastian, Pasqualina/Bessie DeSimone, Clementina Billy, and Philomena Salvatore. The youngest child, Rita, died in infancy. Francis J. Bevilacqua had a distinguished career in politics, serving as a state representative for 22 years from 1958 to 1980.

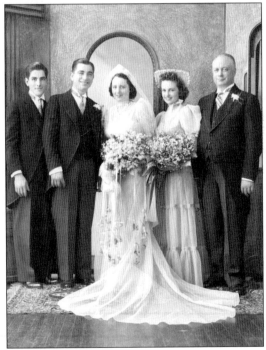

Michael Bevilacqua (1910–1959), second son of Vincenzo and Maria, was best man at the wedding of his older brother Sebastian to Maria "Mickey" Cipolla in 1932. Her attendant was Irene Pitochelli (1916–1998). Six years later, Michael and Irene were married. Irene was the daughter of Pasquale Pitochelli (1888–1958), a barber from Avellino, and Erminia Altieri (see page 88). The Bevilacquas had one son, Paul. Michael Bevilacqua was employed as manager of the meat department of the local A & P store. He was the first person of Italian ancestry to serve as grand knight of the local chapter of the Knights of Columbus and was also the first to serve as district deputy of that organization. From left to right are Vincent DeSimone (the son of Vincenzo and Bessie Bevilacqua DeSimone), Michael and Irene, Evelyn Pitochelli (1919–2001) and Pasquale Pitochelli, Irene's sister and father.

Antonio Pepe (1880–1972) was born in Bonito, Avellino, and came to Haverhill in 1896. His wife, Josephine/Pepina Bevilacqua (1878–1933), was the sister of Vincenzo Bevilacqua from Apice, Benevento. They were married in 1901 and, by the time of the 1910 census, were living at 26 Grove Street, near the Bevilacquas. Antonio was a buffer, or "naumkegger," in local shoe factories. The Pepes had seven children, four of whom survived to adulthood. They are shown in this *c.* 1912 photograph with their two sons. From left to right are the following: (front row) Angelo/Freddie (1908–1938), Josephine, and Sebastian Joseph (born 1910); (back row) Antonio and his niece Speranza Tufo. Other children were Rose (1912–1972) and Bessie (1914–1991).

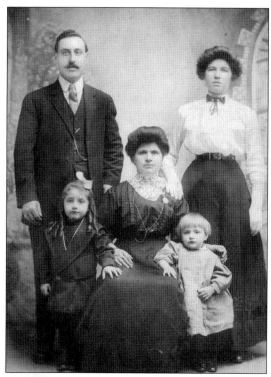

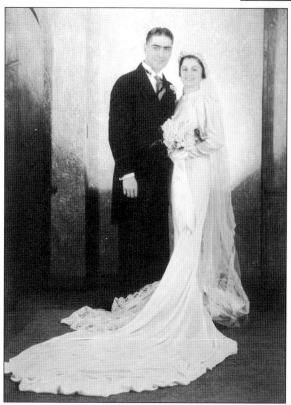

S. Joseph Pepe, son of Antonio and Josephine, married Romilda Carbone (1909–2001), daughter of James and Josie Berisso Carbone (see page 20), in October 1936. Both bride and groom had graduated from Haverhill High School and McIntosh Business College. Romilda had worked as a legal secretary, and Joe was a salesman for United Liquors. He was also one of Haverhill's most popular singers, performing at weddings, celebrations, and a variety of public occasions in a career that spanned the years 1926–1980. The Pepes had a daughter, Ann/Mrs. John Coddaire III.

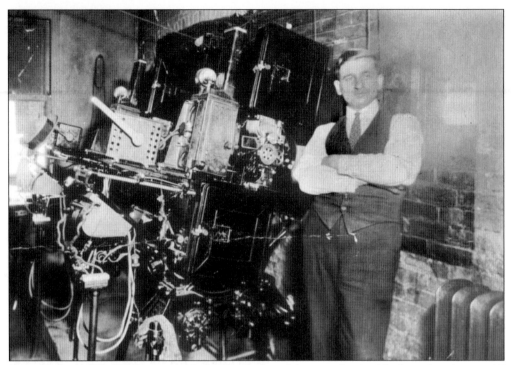

Peter Grillo (1895–1986) came with his family from Marzano Appio, Naples, when he was 16 years old. His parents were Carmen and Pasqualina Grillo. They settled in Lawrence. Peter learned to be a projectionist for the new movie industry. For many years, he was the projectionist at the Colonial Theater in Haverhill, where his brother-in-law Prof. Salvatore Janelli conducted the pit orchestra for the musical performances and stage shows that were performed there. At one time, he was also the manager of the Strand Theater. Both theaters were on Merrimack Street. Peter Grillo married Esther Alvino in 1916.

Esther Alvino (1900–1989) was born in Quindici, Naples, the daughter of Severio and Filomena Alvino. She was about 12 years old when she immigrated with her family to Lawrence. Her marriage to Peter Grillo produced 10 children, three of whom died in infancy. The surviving children were Carmen, Harry, Sam, Gene, Peter, Rita/Mrs. Charles Volpone, and Eleanor. Dr. Gene Grillo served as a Haverhill city councilor for many years. The Grillo family lived in Lawrence until 1939, when they purchased a house on Kensington Avenue, Bradford. They later moved to Laurel Avenue.

Maria DiMonaco (1892–1985), left, was from Casi, Caserta. Jacob Rocco (1887–1945) came from Roccamovina, Caserta. This province is north of Naples. Jacob immigrated at 18 in 1906. He and Maria married in Lawrence in 1910. The family moved to Groveland, where Jacob was a weaver in the textile mills there. Later, Jacob had a real estate business. The Roccos had three children.

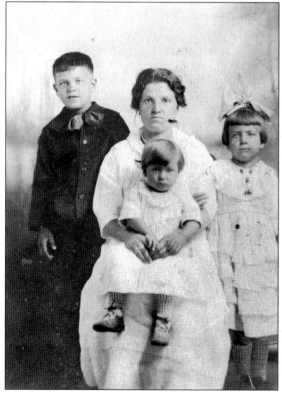

Maria Rocco, wife of Jacob, poses with their three children c. 1924. From left to right are Leo (1912–2000), mother Maria holding Louise (born 1922), and Genevieve (1915–1985). The family lived in Groveland. Louise married Hector Grazio, son of Sebastian and Mary Fido Grazio (see page 36). Genevieve married his brother Anthony Grazio. Anthony was an outstanding banjo player and performed with his band and singer Joe Pepe for a number of years on Boston radio station WHDH.

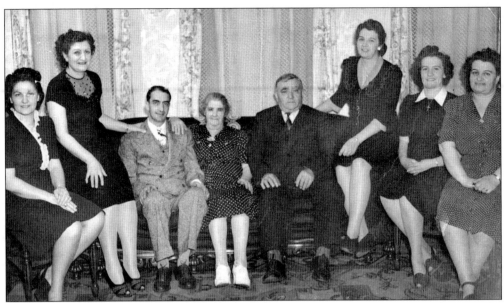

Ralph Iasimone (1881–1959) and his wife, Louise DiAdamo (1876–1949), was born in the Naples area. They married in Lawrence and moved from there to Methuen and then to Derry, New Hamphire, before finding a permanent home on South New Street in Bradford. They had nine children, but two (Philip and Victoria) died as young children and Dominic (1911–1920) drowned in the Merrimack River, which flowed past their corner of Bradford. From left to right are Emma (1909–1999), who married Joseph Pascucci; Matilda (1905–1986), who married Claude Lingo; Arthur (1903–1981); Louise and Ralph Iasimone; Anna (1907–1991), who married Alexander "Sonny" Fantini; Victoria (born 1918), who married George Auclair; and Margaret (1901–1976), who married Joseph Fasulo.

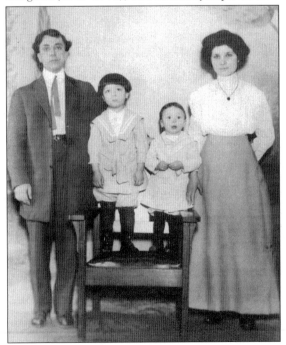

Egidio Dirago (died 1978) married Maria Argenzio (died 1977) c. 1909. Both were from Potenza in the province of Basilicata, which is located southeast of Naples. The Diragos settled first in Lynn, Massachusetts, where their sons were born and then moved to Haverhill. They are shown with their first two sons, Vincent (born 1910) and Emilio. Egidio worked in the shoe shops as an edge trimmer but was also an excellent violinist. In later years, the parents and their adult sons shared a three-family house at 85 High Street. Egidio and Maria lived on the first floor, Vincent and wife Rose (Perrault) on the second, and Emilio and third son, Ernest, on the top floor.

Four

SOUTHERN ITALY AND SICILY

A series of natural disasters hit southern Italy in the first decade of the 20th century. Hundreds were killed in earthquakes in Calabria in 1905. Mount Vesuvius erupted in 1906. An earthquake in 1908 along the Straits of Messina killed 50,000 people in Messina, Sicily, and 12,000 more across the straits in Reggio, Calabria. In 1910, Mount Etna in Sicily erupted. Nicola DeSando (1894–1952), above, was one of many who came to Haverhill from Calabria and Sicily during these turbulent years. The DeSandos were from San Pietro a Maida in Calabria. Nicholas, parents Dominick and Mary, and six brothers and sisters arrived in America c. 1906. Also in the household in 1910 was a second Nicholas DeSando, a 54-year-old cousin of the family.

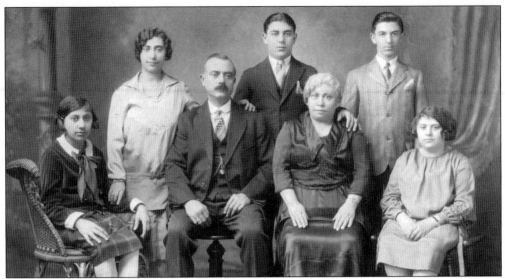

John and Natalina (Marinaro) Coppola from San Pietro were married in 1897. As with many Italian families, John was the first to come to America, leaving his wife and daughter Angela behind. John returned to Italy, fathered a little girl who died during an earthquake, and came back to Haverhill with his wife, Natalina, in 1905. Young Angela was left in Italy and did not arrive until 1911, when she immigrated with her aunt and uncle, Mary Marinaro and Domenic Sgro. John Coppola worked in the shoe shops and, by 1915, had opened a grocery store on High Street. When the 1910 census was taken, John and James DeSando and James's family were living in the Coppola house. The DeSandos were inlaws of Natalina's brother, Domenico Marinaro (see page 101). From left to right are the following: (front row) Mary/Mrs. John Forte (1913–1964), John (1875–1960) and Natalino Coppola (1875–1942), and Concetta/Mrs. Guido Pitochelli (born 1916); (back row) Angela/Mrs. John Procopio (1898–1994), Frank (1908–1979), and Bruno (born 1910).

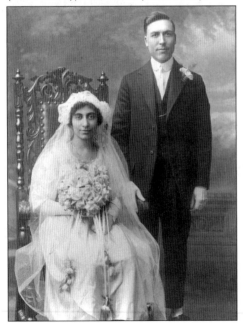

Angela Coppola, oldest child of John and Natalino, married John Procopio (1893–1968) in 1919. John was from San Pietro, the son of Antonio and Concetta Coppola Procopio. When he was about two years of age, his parents, brother Nicola, and John went with two uncles to Brazil, which offered free passage to encourage immigrants. The uncles stayed in Brazil. The Procopios went home to Italy. John immigrated to Haverhill c. 1917. His uncle Nicholas Procopio, who was also in the city, went back to San Pietro to marry. Soon after that, America passed its restrictive immigration laws and Nicholas was unable to return because of the limitations on Italian immigration that were then in force. John worked at the Knipe Shoe Factory in Ward Hill. The Procopios had four children: Concetta/Mrs. Arthur Sannella (1920–1995), Antonio (born 1923), John (born 1929), and Bruno (born 1931).

Frank Coppola, oldest son of John and Natalie Coppola, operated two significant business services in Haverhill. Coppola's yellow school buses began transporting Haverhill's schoolchildren in 1927. Later, he handled the city's refuse service, which he eventually sold. His sons continue to run the school bus service. Frank had only a sixth-grade education, but he was a skilled businessman. He married Nordina Selvaggio from Italy in Haverhill c. 1930. Their attendants were, left, his cousin Katherine Marinaro (see page 101) and, right, cousin Domenic Badolato. The children are, from left to right, Elizabeth Palleria, Tony Procopio, and Connie Procopio.

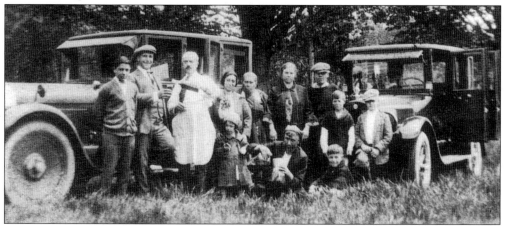

John Coppola, wearing white apron on left, pours wine for Joseph Giampa during a picnic in the early 1920s. In front are Connie Procopio; her father, John Procopio; and Louis Giampa (1914–1988). In the back row are Joseph Giampa Jr. (1903–1988) and his father, Joseph Sr.; John Coppola; Angela Coppola Procopio and her mother, Natalie Coppola; and Rosa Stella Giampa and her three sons, John, Angelo (1912–1993), and Frank. Joseph and Rosa Giampa had been married in San Pietro in 1902 and came to Haverhill in 1905 with their young son Joseph and infant daughter Mary (see page 104). The Giampas also had three other sons: Daniel (who died young), Tony (1916–1991), and Emilio.

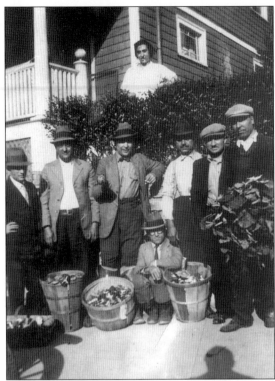

These seven men from San Pietro a Maida had just completed a successful day of mushroom gathering and showed off their spoils for the photographer. From left to right are the following: (front row) Nicola DeSando (see page 97); (middle row) Antonio Selvaggio (see page 103), Michael Serratore, Francesco Paone (see page 89), John Coppola, Nicola Selvaggio (see page 102), and John Procopio; (back row) Angela Coppola Procopio.

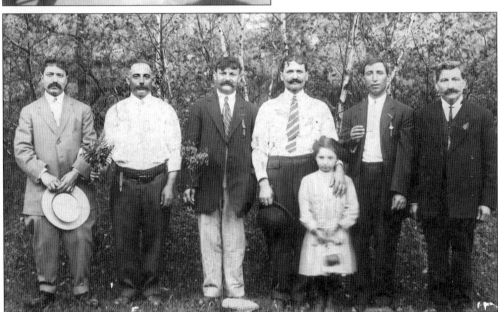

While taking a break during an outing (see page 74), these people posed for a photographer. From left to right are Domenico Marinaro (see page 101), unidentified (possibly a Renda), Joseph Mazzola, Rocco Sapareto and his daughter Victoria (see page 74), Dominic Renda, and Frank Renda. Mazzola (1877–1936), a carpenter, lived on Washington Street and later moved to Lovejoy Street in Bradford. Dominic Renda was a fruit dealer. He lived on Grove Street, as did Frank Renda (1869–1949), a grocer.

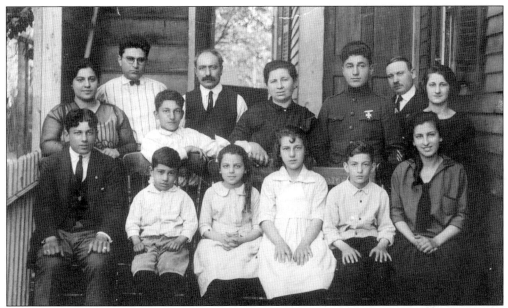

This picture of Domenico Marinaro and his family was taken in 1921. Both of the parents were from San Pietro. Domenico (1873–1943), the brother of Natalina Coppola (see page 98), was a tailor. He worked for many years for tailor Bartholomew Moriarty and later had his own tailor shop in Currier Square. He and his wife, Angela DeSando (1873–1928), had immigrated to New York in 1894. Their first five children were born there. They were in Haverhill by 1905. The Marinaros underwent the tragedy of losing a son during each of the world wars. From left to right are the following: (front) James, Albert, granddaughter Corrine Migneco, Angela/Mrs. A. Biron, Columbus, and Katherine/Mrs. Louis Gardella; (middle row) Dominick (killed in 1945 in France during the war); (back row) Elizabeth Marinaro Migneco, Joseph Migneco, Domenico, Angela, Joseph, an unidentified family friend, and Mary Palma/Mrs. Christos Vissaris. Son Frank Bruno (1900–1918) died during World War I while serving in the U.S. Navy.

Francesco Azzarito (1888–1981) was from San Pietro a Maida. He came to the United States c. 1916 and served in the U.S. Army during World War I. He returned to Italy in 1920 to marry Angelina Costantino (1897–1974), also of San Pietro, and they came back to Haverhill just ahead of the new immigrant quota system. Frank was a mason. This family picture dates from c. 1925. From left to right are Frank holding Antonio (born late 1923, died 1930), Antonetta (born early 1923, died 1928), Angelina and daughter Angelina (1921–2000). Three children were born after the picture was taken: Dominic (1926–1998), Antoinette (born 1931), and Frank (born 1934).

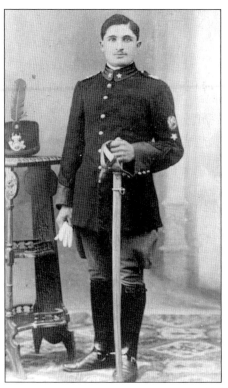

Nicola/Nicholas Selvaggio was born in 1891 in San Pietro a Maida to Vito and Maria Iuele Selvaggio. He served in the Italian cavalry during World War I before immigrating to America. Nicholas worked as a landscape gardener and, in his later years, at the Wood textile mill in Lawrence. Nicholas died in 1976.

Nicholas Selvaggio married American-born Angela Adzarito (1904–1970). She was 15 at the time of her nuptials. Her parents, Nicholas and Victoria (Talarico) Adzarito, like her husband, were originally from San Pietro. The Selvaggio family included, from left to right, the following: (front row) Nicholas, Victoria/Mrs. Robert Hammond (born 1929), and Angela; (back row) Vito (born 1920) and Josephine/Mrs. Hector Bassi (born 1925). Angela worked at the Stevens textile mill by the Little River in Haverhill (see page 106).

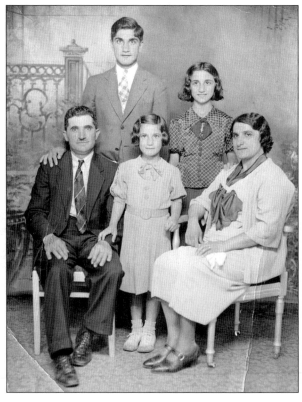

Antonio Selvaggio (1898–1977) was the younger brother of Nicholas. He also served in the Italian army and immigrated to Haverhill. The Selvaggio brothers had two sisters, Caterina and Maria, who married and remained in San Pietro. Antonio Selvaggio married Maria DeSando (1909–1987). They had four sons: Vito, Richard Marco, and twins Donald and Ronald. Antonio was a musician. He is shown holding a baritone horn in 1930 with the Haverhill City Band at the Haverhill Firemen's Relief Association Parade. His sons continued the family music tradition as musicians and teachers of music.

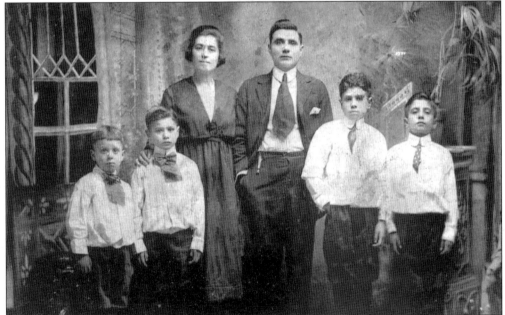

Domenico Palleria (1885–1957) married Adelina Borrelli (1892–1973) in 1907. She was from Wilmington, Delaware, and was only 15 at the time of the marriage. When Domenico took his new bride to his home in San Pietro a Maida, his family insisted on dressing the American bride as "a little peasant girl" and had the couple remarried in the local church. This picture of the Palleria family was taken c. 1918. Two more children, Elizabeth (born 1920) and Edith (born 1934), were born later. From left to right are Frank (1913–1929), Nick (1911–1996), Adelina, Domenico, Tonio (1908–1987), and Joseph (1909–1997).

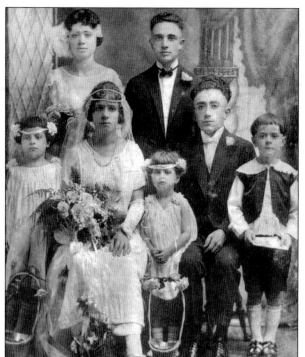

Dominick Pallaria (1895–1975)—a cousin of Domenic Palleria (see page 103), despite the variations in spelling—married Mary Giampa (1905–1995) in 1923. Both were from San Pietro. Mary immigrated as an infant with her parents Joseph and Rose (Stella) Giampa (see page 99). Dominick, who had been apprenticed as a blacksmith in Italy, continued that work with his father in Haverhill before becoming a shoe worker at the Knipe Shoe Factory. The wedding party for Mary and Dominick included, from left to right, the following: (front row) Gilda Davoli, Mary Giampa, Elizabeth Palleria, Dominick Pallaria, and Nello Pace; (back row) Elizabeth "Petina" Serratore and Antonio Selvaggio (see page 103).

Dominick and Mary Pallaria had six children. The family lived on Front Street in Bradford on the edge of the Wood School playground, a trolley ride away from the father's work in Ward Hill. From left to right are the following: (front row) Rosie (born 1933), Frank (born 1934), Marion (born 1935), and Mary (born 1926); (back row) Joseph (born 1929) and Dominick Jr. (born 1927).

John and Angela Coppola Procopio celebrated their 25th wedding anniversary in 1944, and the event was a mini-reunion for these women with San Pietro a Maida ties. From left to right are the following: (front row) Dena D'Arcangelo/Mrs. Bruno Coppola; Angela Procopio; Mary Giampa Pallaria; her mother, Rose Stella Giampa; and Angela's sister Connie/Mrs. Guido Pitochelli; (back row) Angela Adzarito/Mrs. Nicholas Selvaggio; Angela Papatola Sirois; Mariana Stella DeFazio, Rose Giampa's sister; Concetta Coppola Papatola (1883–1966), mother of Angela Sirois; and Mary Coppola/Mrs. John Forte.

Marion Nisdeo (1906–1967) immigrated from San Pietro a Maida in 1915 with her parents, Joseph (1877–1954) and Caterina Tedesco Nisdeo (1880–1946). They lived at 3 Verndale Street in Bradford, near the Wood School. Marion married Achille D'Orazio (1896–1977), left, in 1928. Marion is shown on the right of this photograph. Achille was from Bisegna, Abruzzi, and was the son of Antonio and Maria Forte D'Orazio. He immigrated when he was 17 and was employed as a shoe worker and shoe salesman. Achille and Marion had four children: Anthony, Elena, Norma, and Joseph. The family first lived on New Hampshire Avenue in Bradford and then moved to the Verndale Street house of Marion's parents.

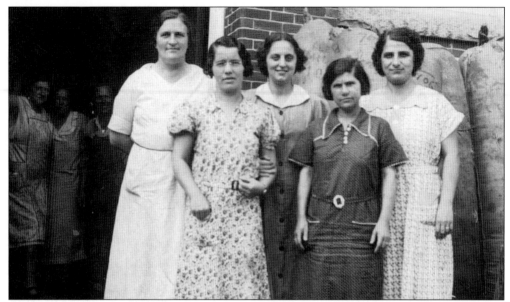

A great number of Italian immigrants and their children found employment in Haverhill's shoe shops. A lesser number worked at the city's one textile mill, the Stevens Company on Winter Street. From left to right are the following: (front row) Amalinda Condini and Alice Dean; (back row) unidentified, Josephine Iuele Giampa (daughter of James and Mary Iuele of San Pietro), and Angela Adzarito Selvaggio.

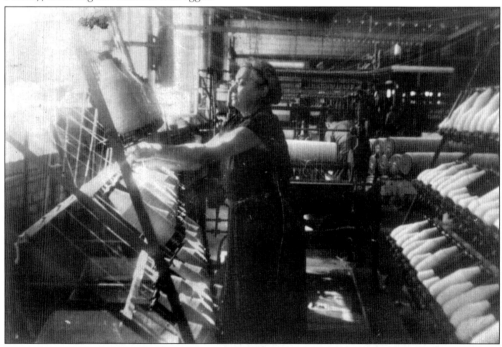

Mary Greto Iuele (1888–1988) was the wife of James Iuele (1878–1949). They were both from San Pietro. She is shown working in the spinning room at the Stevens Company. James Iuele was a cousin of Nicholas and Antonio Selvaggio. The Iueles had four children: Mary (born c. 1907), Anthony (born c. 1908), Frank (born c. 1912), and Josephine (born c. 1913).

Nicholas Azzarito, the son of Nicholas and Antoinette, was born in 1897 in San Pietro. He came to America in the 1920s and worked as an electrician. In 1929, Nicholas married American-born Silvia Selvaggio, also known as Salvani. She was born in 1908 to John and Maria (Astorina) Selvaggio. The Azzaritos had four children: Antoinette Rita, Mary Rose, Alba Silvia, and Nicholas Joseph. Silvia Azzarito was widowed when Nicholas died in 1967.

Emanuel (1864–1919) and Mary Concetta (Scalese) Mascaro (1867–1942) were from Angoli, which is north of San Pietro in Calabria. They were married in Angoli c. 1895. Five children were born in Italy, three of whom survived. Emanuel came to America in 1900 to Winsted, Connecticut, where Concetta's brother lived. He then moved to Haverhill. His wife and three children arrived in 1907. The family lived on Cogswell Street, at the upper end of Hilldale Avenue. Around them was a neighborhood of fellow immigrants from their part of Calabria. Emanuel died during the flu epidemic in 1919. From left to right are the following: (front row) Bessie/Mrs. Sam Lucia (1896–1994), Mary Scalese Mascaro, and Joseph (1898–1986); (back row) Emanuel and Mary/Mrs. Vito Butruccio (1897–1961).

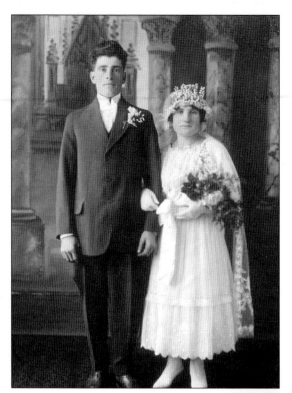

Serafino/Sam Lucia, born in Migliuso, Calabria, in 1893, arrived in Haverhill in 1912. He had been crossing the Atlantic when the *Titanic* went down. Sam married Basalina/Bessie Mascaro in 1917. She was the daughter of Emanuel and Mary Concetta Mascaro. The Lucias had two children, Constance and Frank. Sam was a laborer who worked on such major construction projects as the bridge over the Merrimack River, now called the Basiliere Bridge, and the Haverhill Post Office. Sam died in 1984, some 10 years before his wife of 65 years died.

Sam and Bessie Lucia and their two children lived in the Mascaro family home after the death of Emanuel during the 1918–1919 influenza epidemic. This photograph was taken c. 1933. From left to right are the following: (front row) Sam Lucia, Concetta Mascaro, and Frank Lucia; (back row) Constance and Bessie Lucia. Frank Lucia became the third person of Italian descent, along with Hugo Taglieri and Hector Perrone, to be accepted into the Haverhill Fire Department.

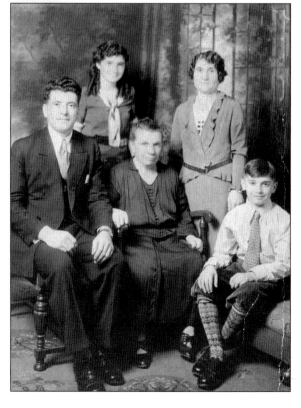

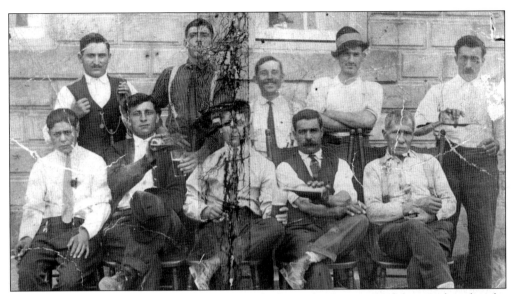

This group of men from the villages of Migliuso and Angoli, Nicastro, Calabria, gathered at the home of Nicola (1875–1969) and Maria (1880–1968) Caradonna to celebrate their wedding in 1914. They all lived in the Eudora/Cogswell Street area of upper Hilldale Avenue. From left to right are the following: (front row) Pepe Gilotti, Joseph Lucia, Mike Gilotti, James DeFazio, and unidentified (but remembered as someone who was killed at the Haverhill Boxboards); (back row) unidentified (returned to Italy), Serafino Lucia, unidentified (returned to Italy), Frank Farina, and Annibale DeFazio

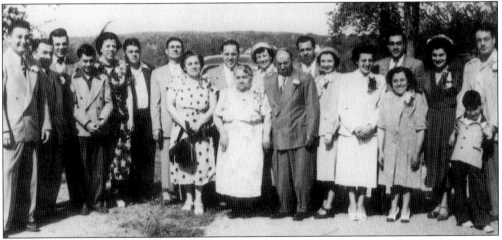

Annibale DeFazio (1882–1958) and Pasqualina Rizzo (1882–1964) married in their native Nicastro, Calabria, in 1900. Annibale was the first to come to Haverhill and, in 1913, after several trips to Italy, he was able to bring his wife and three children to Haverhill. The DeFazios built a home on Bennington Street behind their 491 Hilldale Avenue store. The DeFazio family of four generations gathered in 1950 to celebrate the wedding of daughter Caroline "Kelly" to Emile Ouellette. From left to right are the following: (front row) Mary DeFazio Zingale, Pasqualina, Annibale, Claire Foynes DeFazio, Josephine and Louise DeFazio; (back row) Louis Zingale, James DeFazio, Joseph Mazza Jr., Albert Mazza, Rose DeFazio Mazza, Joseph Mazza Sr., James Zingale, Emile and Caroline DeFazio Ouellette, Tony DeFazio, Ernie DeFazio, Rose Zingale Gullo, and James Gullo with son James Jr.

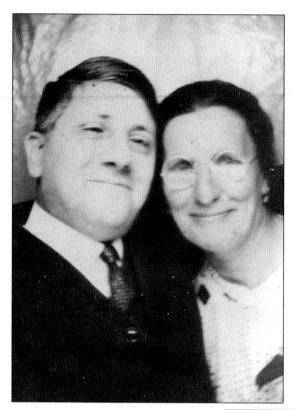

Serafino Colantoni (1888–1957) was born in Pecina, Calabrese, and immigrated to America in the early 1900s. He married Maria Albanese (1890–1937), the daughter of Tony and Elizabeth Albanese. Her parents and five children came to America in 1892. Serafino/Sam was a shoe worker. The Colantonis had seven children: Stafford Antonio Vincenzo (1912–1984), Agnesa/Mrs. Arthur Anderson (1914–1978), Elizabeth/Mrs. Richard Demaris (born 1916), Joseph (1917–1981), Peter Nestor (1919–1963), Anthony Paul (1921–1991), and James (born 1926). Sam and Maria are shown in 1935, two years before Maria died.

Grace Ragni/Renda (1887–1973) and Lorenzo Panaro (1880–1964) were from Altamari, Bari, in Apulia on Italy's "heel." They married there in 1904 and were in America by 1910. Lorenzo was the son of Joseph and Grace Panaro. Grace was the daughter of Paul and Katherine Ragni (also known as Renda). The Panaros had 13 children: John, Grace/Mrs. Angelo Somma, Katherine/Mrs. Joseph Romantelli, Mary/Mrs. Joseph Pappalardo, Rose, Pauline/Mrs. Thomas Blasi, Andrew, Paul, Joseph, Agnes/Mrs. Albert Eafalla, Frank, Lawrence, and Richard. Andrew, Paul, and Richard died in infancy. Lorenzo was a cement finisher and a shoemaker, and Grace was a seamstress.

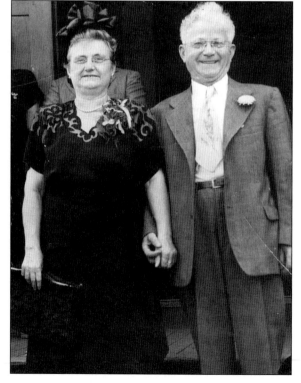

Joseph Lomazzo (1870–1952) and Grace LaSorsa (1874–1961) were both born in Bari, Apulia. This is on the Adriatic coast of Italy. They married c. 1898 and immigrated to America c. 1905. Joseph was a construction worker. The Lomazzos had five children: Antonio, Joseph, Michael, Mary, and Anna. The family lived on Temple Street. Joseph and Grace are shown with their grandson Philip Lomazzo.

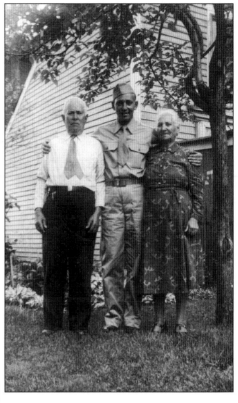

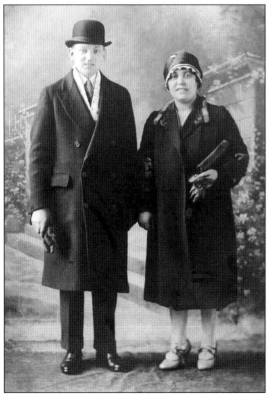

Antonio Lomazzo (1900–1967) immigrated with his parents, Joseph and Grace, when he was five years old. He married Anna Bonvino (1901–1981) in 1922. Anna was also from Bari, but she did not immigrate until 1919. Joseph had been in the music business on River Street when he purchased two stores across from his business and remodeled them into his first restaurant, La Cantina. A year later, he moved the restaurant to 13 Merrimack Street and renamed it Lomazzo's. When fire destroyed that building in 1965, he purchased the Bella Vista restaurant on Pilling Street and reopened it a year later as Lomazzo's Bella Vista. With his sons Joseph, Michael, and Philip, he also ran a catering service, a restaurant at Hampton Beach, New Hampshire, and for a number of years operated the clubhouse at the Haverhill Country Club.

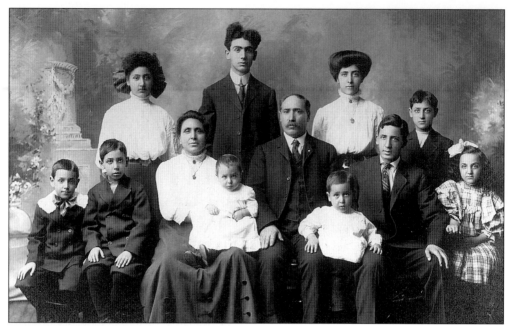

Gabriel Pelosi (1864–1946) was born in Anzano di Puglia, Foggia, Apulia. He married Mariantonia Zizza (1863–1947) in 1886. She was born in San Sosse, Baronia. The Pelosis immigrated with their first three children in 1895. Eight children were born in America. This picture is dated 1907. From left to right are the following: (front row) Alfred (1903–1956), Francis (1899–1948), Mariantonia holding Victor (1907–1986), Gabriel, Theodore (1905–1979), Amedio/Mittie (1893–1984), and Celia (1901–1945); (back row) Amelia (1896–1932), Rocco (1888–1919), Rose (1889–1977), and Nicholas (1897–1912). Rose married Leone D'Assis, Amelia married Angelo Colangelo, Celia married Michael Zizza, Theodore married Anna Fitzgerald, and Victor married Violet Takesian. The others remained single. The 1910 census lists an infant, Meddie, who died young.

Theodore Pelosi Jr. (born 1926), grandson of Gabriel and Mariantonia, is shown in the uniform of the Michael Bucuzzo Post Drum and Bugle Corps in 1939. He was the first Italo-American to be elected mayor of the city of Haverhill (1988–1993). He served on the Haverhill City Council for a total of 20 years between 1962 and 1987. During his last 11 years on the council, his colleagues chose him to be the president. Pelosi was a bass drummer in the Michael Bucuzzo Post Drum and Bugle Corps that had been organized in 1937. It marched for the last time in October 1942, before World War II deprived it of its members.

Angelina Boltasarri Cagnetta (1893–1947) was the wife of Frank Cagnetta (1891–1973). They were born in Darlice, Bari. The Cagnetta family lived on Washington Avenue. Angelina is shown with three of her six children. From left to right are Mary/Mrs. Tom Curcio (born 1921), Jenny/Mrs. Anthony DiPalma (born 1927), Angelina, and Pasquale (born 1929). Other children included Lena, who was born in Italy c. 1920, Frances "Kiki"/Mrs. Ralph Abbott (1923–1982), and Pasquale (1925–1926). Mary Curcio operated the Mayfair and the Academy beauty shops. This photograph was taken in 1935 on River Street near the Victor Emanuel Lodge.

Antonio Guaetta (1895–1999) from Sicily had served in the U.S. Army during World War I soon after he had immigrated to this country. He moved to Haverhill after the war and, in 1920, married Angelina Bitonti. Angelina (1896–1984) came from Calabria. Antonio was a barber, working first for the Broderick-Collins shop and later in his own shop. From left to right in this c. 1929 photograph is Daniel Broderick, Stephen Collins, and Antonio.

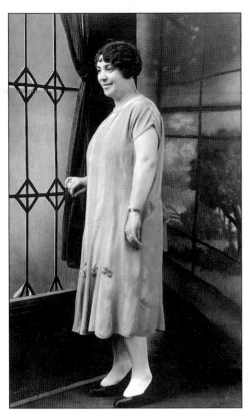

Lena Mazzotta was the eldest of the four daughters of Anthony and Sebastiana Mazzotta. Born in Catania, Sicily, in 1900, she immigrated with her father and sister Rena (see page 30) *c.* 1916 after the death of her mother. Lena married Paul Pecci from Abruzzi (see page 45). Lena was a housewife. She and Paul had a daughter, Phyliss, and the family lived first on River Street and then moved to Fountain Street in the Highlands area of Haverhill, next door to sister Rena and her husband, Fred Bacigalupo. Lena died in 1995.

Jane Mazzotta, youngest of the four Mazzotta sisters, was born in 1909. She came to Haverhill *c.* 1920 as a child and lived on Fountain Street. Mazzotta went to Haverhill schools and Bridgewater State College. She later became a music teacher, serving on the staff of the Tilton School for more than 40 years. Mazzotta married Angelo Benedetti (1900–1990) *c.* 1955. Angelo was the son of Joseph (1875–1964) and Ernesta Benedetti (1875–1943). Mazzotta died in 1993. The fourth Mazzotta sister, in addition to Lena, Rena and Jane, was Carmen, who married John DiCorpo.

Vincenza "Jennie" Gianni, born in
Catania, Sicily, in 1886, emigrated from
Italy *c.* 1925 to become the second wife of
Anthony Mazzotta (1875–1963) and
stepmother to the "Mazzotta girls."
Vincenza and Anthony had a son Arthur
(1926–1969). Vincenza Gianni Mazzota
died in 1967.

Catherine Nilo Gianni (1863–1943) was the
mother of Vincenza Gianni Mazzotta. She
emigrated from Catania, Sicily, *c.* 1926 to live with
her daughter and husband on Fourth Avenue.
When World War II broke out, Catherine, then in
her eighties, found herself in the embarrassing
position of having to register as an "enemy alien"
because the United States was at war with Italy.
Catherine died in 1942.

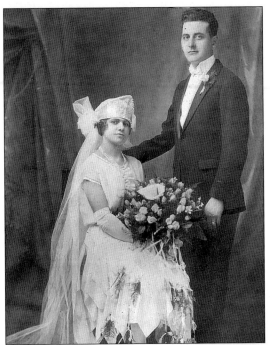

Salvatore/Sam Caruso (1897–1967) and Jennie Zappalla (1903–1972) were both Sicilians. Caruso was born in Via Grande and Jennie in Asti San Antonio, both part of Catania. Sam immigrated with his father c. 1910 and served in World War I. Jennie came a few years later. They were married in 1925. The Caruso family lived on River Street, where Sam operated the Radio Bakery and delivered his Italian bread throughout Haverhill and as far as the beaches. There were six Caruso children: Nicolina, Thomas, Corrado, Rose, Frank, and John. Early in the 1930s, the family had moved to Verndale Street in Bradford and, in 1941, purchased a house at 562 South Main Street. The Carusos operated a fruit and vegetable stand and variety store from a shop in front of their house until Caruso's death in 1967. Jennie died in 1972.

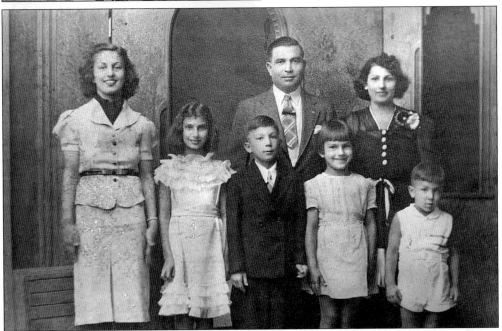

Joseph Piccolo (1892–1963) was born in Barcelona, Sicily. He immigrated to America and was working in a factory in Fitchburg, Massachusetts, when he met Maria Tomasello (1902–1938). She had been born in Salece, Sicily. They married and established their home in Haverhill. The Piccolos had five children: Santa/Mrs. Joseph Januszewski (born 1921), Grace/Mrs. Austin Jameson (born 1926), Mariano/Morris (born 1929), Rose/Mrs. E. Palmer (born 1931), and Daniel (born 1933). When Prohibition ended, Joseph obtained the first liquor license to be issued in Haverhill and operated the Brown Derby Café at 60 Washington Street.

Giuseppe (1861–1941) and Filippa Cordio Palermo (1880–1928) from Sicily had seven children: five daughters and two sons. The daughters posed for this picture c. 1918. From left to right are the following: (front row) Olimpia/Mrs. Salvatore Fasullo (1891–1979); (back row) Frances/Mrs. Santo Gucciardi (1899–1964), Mary/Mrs. Rosario Anzaldi (1895–1947), Eva/Mrs. Ignazio Cavaretta (1896–1981), and Anna/Mrs. Sam Sciuto (1904–1958). The two Palermo sons were Ignazio (1888–1959) and Salvatore (1889–1974). Ignazio was married three times: Mary ?, Lucia Mirable, and Christine Ross Fruci. Salvatore's wife was Josephine Mirable (1893–1966). Giuseppe and Filippa lived with their daughter Mary Anzaldi at her home on Arch Avenue.

Ignazio Cavaretta (1893–1980) immigrated to America c. 1909 when he was 16. He served in the U.S. Army in World War I and was an active member of the Michael Bucuzzo Post in the decades after the war. Cavaretta was a shoe worker. He married Eva Palermo (1896–1981) in 1920. Eva had come to America with her family when she was 12 years old, c. 1908. She, too, was a shoe worker. The Cavarettas had two children: Mary Ann, who married Joseph Lomazzo (see page 111), and Phyliss, who died in infancy. From left to right are Ignazio, Mary Ann, and Eva in this mid-1920s photograph.

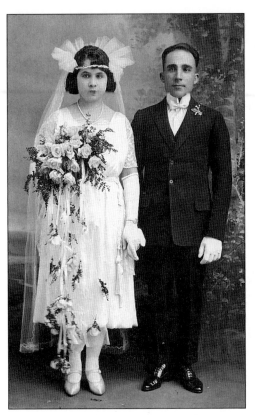

Frances Palermo, younger sister of Eva, married Santo Gucciardi (1890–1976) in 1921. Both had been born in Sicily. Frances immigrated with her family and Santo with his brother Antonio. He also had a cousin, Steve Gucciardi, who married Rose Fiorentini. Santo was a soldier in World War I. After the war, he worked as a mason, including such landmarks in Haverhill as Hasseltine and Denworth Halls at Bradford College, the Washington Square Post Office, and the Haverhill Stadium. Frances and Santo had one child, Diana/Mrs. Gordon Melendy.

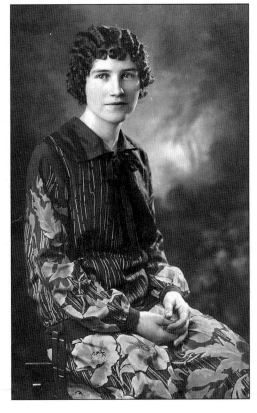

Margaret DeFeo (1909–1965) was born in Haverhill, the daughter of Patsy Defeo from Sicily and Felicia Barone from Naples. She was married in 1931 to Fred Ferlito (1910–1945), one of the original members of the Victor Emanuel Lodge Drum and Bugle Corps. Fred was the son of Gaetano and Rose (Reitano) Ferlito from Sicily. Fred and Margaret had one son, Tom. This picture dates from c. 1935.

Paolo Fici (1891–1945) was from Salemi, Sicily, but his family was originally from Genoa. He was sponsored for immigration by the Accardi family. Paolo married Maria Scovotti (1895–1968) in 1914. She was from Salerno, Campania. Paolo worked as a stonemason before being hired by the Haverhill Gas Company. He worked for the company for the rest of his life. In this 1928 family portrait, from left to right, are the following: (front row) Tony (born 1916), Maria, Joseph (1922–1989), Emanuela/Mrs. Ernest Duchemin (1917–1994), and John (1915–1998); (back row) Paolo. The family home from the mid-1930s was on South Prospect Street in Bradford.

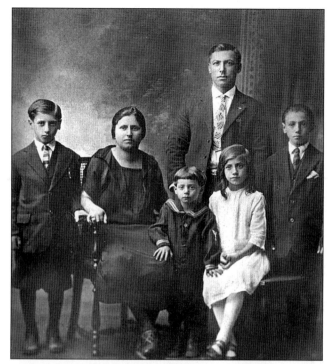

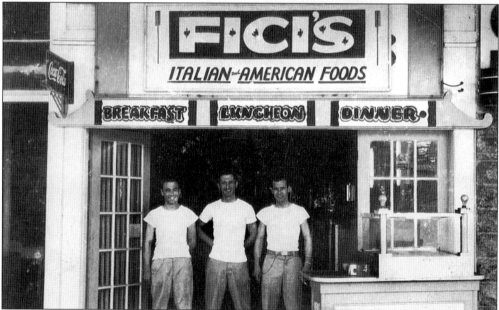

John and Joseph Fici were best known as the proprietors of Fici's Barber Shop, an establishment they operated for over 55 years. However, one of their early ventures was this Salisbury Beach restaurant, which they owned with their brother Tony. While John and Joe ran their barbershop, sister "Manny" was a sample stitcher, a floorlady, and ultimately supervisor of the stitching and fitting rooms in local shoe shops. Brother Tony was also employed in the shoe industry. From left to right are John, Tony, and Joseph Fici at their Salisbury Beach shop in 1947.

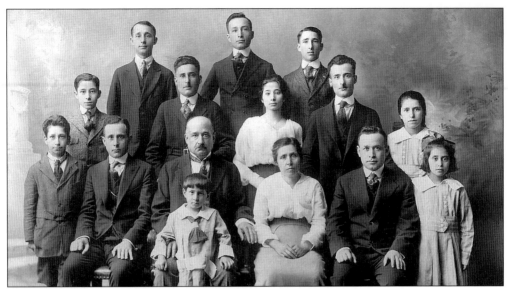

Vincenzo Scamporino (1863–1941) and Lucia Misenti (1866–1940) married in Syracuse, which is on the southeast coast of Sicily, c. 1885. Twelve children were born in rapid order and the 13th, Remo, was born after the family had settled in Massachusetts. From left to right are the following: (first row) Remo/Raymond (1913–1977); (second row) Romeo (1906–1963), Pietrino (1888–1957), Vincenzo, Lucia, Emilio (1886–1954), and Elena/Mrs. Nicholas Fiorello (1908–1986); (third row) Ottavio/John (1902–1944), Geoffredo (1893–1971), Virginia/Mrs. Gene DiBurro (1898–1977), Guido (1895–1992), and Aldina/Mrs. Anthony DeCesare (1904–1987); (fourth row) Egidio/Patsy (1891–1951), Amilcare/George (1889–1958), and Settimo (1901–1977). Vincenzo operated a store at the corner of River and Ayer Streets. Many of his children were connected to the restaurant business, both in Haverhill and throughout New England.

Prof. Salvatore Janelli was the director of the Italian Band of Haverhill, the manager of the Majestic Theater, and leader of the theater orchestra from 1911 to 1922, when the theater featured stage shows, musicals, and silent movies with musical accompaniment. He was also a teacher of piano and voice. Salvatore married Carmella Grillo, sister of Peter Grillo (see page 94). He served as master of ceremonies and chairman of the ceremony when a statue of Dante Alighieri was presented to Haverhill High School in 1921. A bust of Dante was given to the public library on the same date to commemorate the 600th anniversary of the death of Dante Alighieri. The Janellis had two children who were born and died in Haverhill. The Janellis returned to his home in Sicily. World War II kept them from coming back to Haverhill. Their daughter Sophia is the modern-day poet laureate of Sicily.

Five

THE ITALIAN COMMUNITY IN HAVERHILL

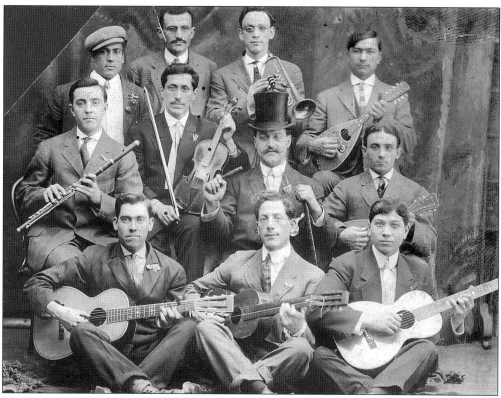

This group of Italian musicians played for weddings, christenings, anniversary celebrations, and other occasions that called for music. The picture dates from c. 1915. From left to right are the following: (front row) Michele Lupi, Ferdinando "Fred" Scatamacchia, and Vicenzo Calvani; (middle row) Pietro Losti, Giovanni Forte, unidentified, and Giuseppe Spera; (back row) two unidentified singers, Nando Conforti, and Nicola Carrozza. (One of the unidentified men could be Tony Coronetti, who is listed in the 1910 census as a singer).

Victor Emanuel Lodge, Sons of Italy, organized a drum and bugle corps in 1939. This photograph is of the original corps and was taken in 1940 in front of the Bartlett School, Washington Street. From left to right are the following: (first row) James Giardini, Charles Danese, Anthony Filomeno, Alfred Ferlito, Pasquale Filomeno, majorette Frances Nilio, Peter DeFlorio, Antonio Blasi, John Fici, Frank DiStefano, and Stephen Anzaldi; (second row) Joseph Yannalfo, Guistino Franzone, Alfred Barberio, drum major Lawrence Durso, Vincent DiProfio, Gennaro Spinelli, Joseph Nilio, and Anthony Spinola; (third row) Hugo Gardella, Anthony DiBartolomeo, George Forte, Dominic Filomeno, and Rocco Lanza; (fourth row) Dominic Accardi, Alfred Franzone, Carmen Basso, Vito Selvaggio, and Richard Conforti; (fifth row) Alfred Fantini, Arthur Ferona, Nicholas Augusta, Anthony Basso, William Augusta, and Angelo Cusano.

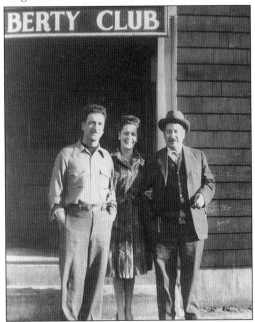

The Liberty Club on River Street was a home away from home for many of the older generation of Italian men, including Carmine DiBartolomeo (see page 59). They could play cards inside or bocce ball on the court in back, or just sit and talk. Carmine is shown in front of the Liberty Club with his daughter Domenica Mary (born 1917) and her husband, Thomas Sotera (born 1915). Sotera had a long and distinguished career of service to Haverhill. He was city assessor, chairman of the planning board, commissioner of public works, and a president of the Lions' Club.

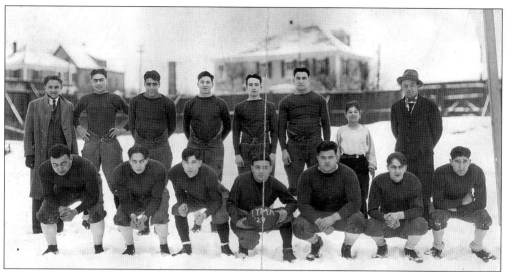

Haverhill witnessed many forms of athletic competition among the various ethnic groups and neighborhoods in the decades between the two world wars. This is the Italian Young Men's Association semiprofessional football team, 1929. From left to right are the following: (front row) Dan Benedetti, Tony Basso, Michael Bevilacqua, Tony Scalese, Marcellus Benedetti, Carmen Basso, and Chili Giardini; (back row) Fred Basile, Joe Pepe, Bernard Lebro, Pip Grassi, A. Gardella, Nazaire Benedetti, Chick Barberio, and coach Nordo Nissi.

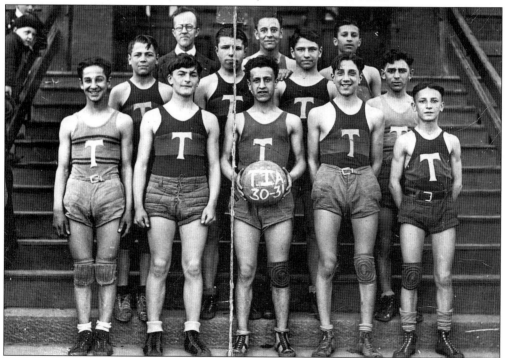

This is the Tilton School basketball team of 1930–1931. From left to right are the following: (front row) Frank Barberio, Tom Gordon, Tony Cortese, Frank Puglisi, and Aggie Eliopoulos; (middle row) Romeo Emilio, Tony Kozub, Joe Benedetti, and George Varhatos; (back row) Coach Raymond Ingham, Emile Surette, and Sam Conte.

This Haverhill High School basketball team won the 1945 Essex County championship and played in the state tournament. All of the members lived in the same neighborhood, and four of the five were of Italian descent. From left to right are Al Emilio, Larry Panaro, Anthony "Tiny" Augusta, Deno Valoras, and Rico Carifio. Emilio was a three-sports star. He was the leading scorer on the basketball team, quarterback of the football team, and an ace pitcher on the baseball team.

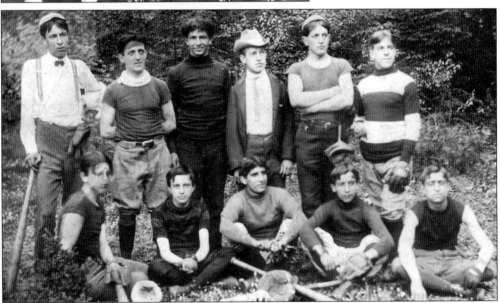

These young Italian immigrants and their American-born cousins quickly adopted the American passion for baseball. They called themselves the Italian Athletic Club. The picture dates from c. 1900. From left to right are the following: (front row) Natale Parodi (son of John and Josephine); Louis Fopianno (son of Joseph and Caterina); Nick DiTommaso (son of Giovanni and Rose); Willie Casazza (son of John and Provi); and Paul Cosio (son of Frank and Annie); (back row) Louis Oneto (son of Nicholas and Laura); Alex and James Tuccolo (sons of Antonio and Filomena); and Charles, Fred, and John Carbone (sons of Giovanni and Cecilia).

Columbus Athletic Club baseball team is shown *c.* 1905. From left to right are the following: (front row) Mitty Beneditto, Willie Casazza, and Paul Cosio; (middle row) Louis Fopianno, Gus Cosio (son of Frank and Annie), Michael Gardella (son of Frank and Celestina), and Gusty Gardella (son of Angelo); (back row) Romeo Casazza (son of Michael and Maria), Joe Ferronetti (son of Charles and Louise), John and Joseph Gardella (sons of Frank and Celestina), Charlie and Andrew Gardella.

The Modern Billiards softball team, shown *c.* 1950, included some of the best of a younger generation of athletes of Italian ancestry. From left to right are the following: (front row) bat boys Joey Serratore and Tony Giampa; (middle row) Dante Gobbi, George Tashjian, Eddie Schena, Rico Carifio, and Frank Panaro; (back row) "Ricka" Serratore, Mario Pagnottaro, Al Emilio, Ralph D'Arcangelo, Eddie Carifio, Joe Pazzanese, Bob Fantini, and "Blacky" Accardi.

The Italian American Credit Union was founded in 1934. It provided a sound financial institution for the Italian community at a time when the Great Depression was wreaking havoc with local banks. These directors shown in this c. 1948 photograph include many that were among the original incorporators. From left to right are the following: (front row) Anthony Basso, attorney Philip DiBiasio, Orestes Grassi, and Michael Cortese; (back row) Bruno Coppola, Augusto Fiorentini, Jack DiBurro, Sam Comei, Mario Battistini, Rocco Forte, Mario Sirry, Bernardino Minichiello, and Armando Bologna.

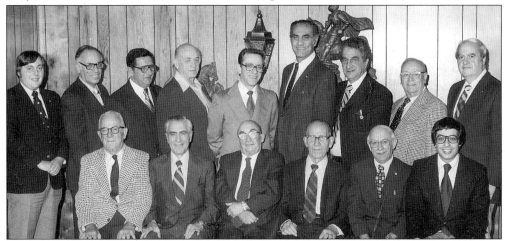

The directors of the Italian American Credit Union in 1980 included a mix of some original members and a younger generation of Italian-Americans. From left to right are the following: (front row) Anthony Basso, S. Joseph Pepe, attorney Philip DiBiasio, Sam Comei, Bruno Coppola (president), and Peter Dibitetto (manager); (back row) attorney William Faraci, John Anzaldi, Sam Amari, Hugo Scattamacchia, Frank Pallaria, Fred Battistini, John Sapienti, Michael Cortese, and Joseph Cardarelli.

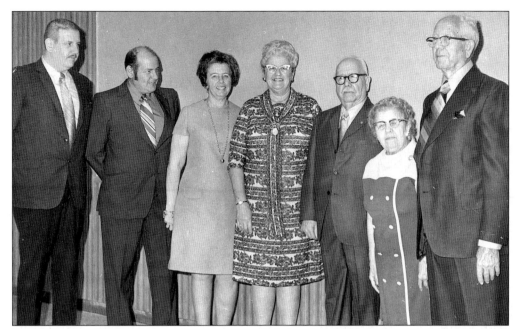

In 1969, Dr. Albert Consentino was rewarded for decades of service to the Haverhill community—in particular for his 20 years on the Haverhill School Committee—when the new middle school on Silver Hill was named for him. Shown at the ceremony, the members of his family are, from left to right, sons Philip and Albert Jr., daughter Eleanor Feuer, wife Delia Araldo, Dr. Consentino, twin sister Mary, and brother Joseph Consentino.

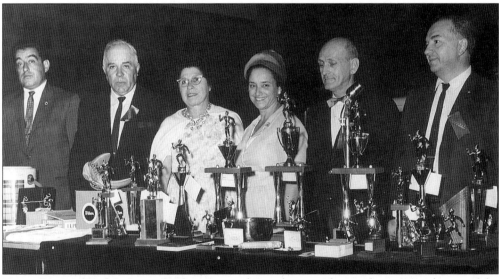

Victor Emanuel Lodge, Sons of Italy, sponsored a road race each year that attracted some of the top runners in the region. This is the committee for the 1964 race. From left to right are Sal Urso, Joseph Durso, Rose Esposito, Jennie Volpe (wife of Gov. John Volpe), John Danese Sr., and Michael Schena. Joseph Durso was the first person of Italian descent to be elected to the Haverhill City Council. Rose Esposito was the second woman to hold the title of venerable in the lodge. Mike Schena directed these BAA-sponsored races for decades. He also directed the Golden Gloves boxing matches in the city.

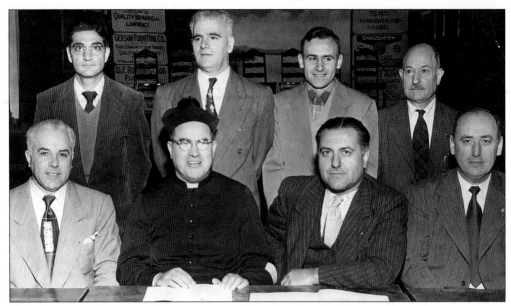

For many Italians, St. Rita's was their personal parish. The church was built in 1915 as a mission to the St. James parish. It became a separate parish in 1932 with Rev. Dr. Irving Gifford as the first pastor. The parish offered religious services in the Italian language and special devotions to beloved Italian saints. Shown c. 1950 are the officers of the Holy Name Society, an organization for men. They are, from left to right, as follows: (front row) Alderman Joseph J. Durso, Rev. Daniel Taglino, attorney John Dondero, and unidentified; (back row) Victor Adzarito, Angelo Benedetti, Salvatore Amari, and Carmine Leuzzi.

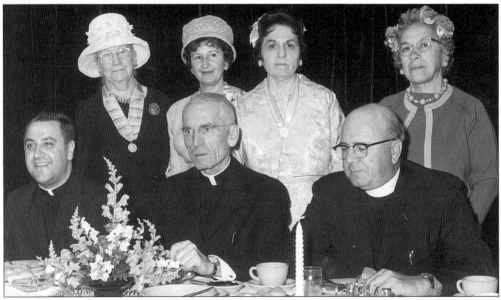

The principal women's group at St. Rita's was the Sodality. In 1962, the group sponsored a mother-daughter tea and invited a familiar face to be the guest speaker. From left to right are the following: (front row) Rev. Ernest Serino, a former assistant at the church and guest speaker; Rev. John Sheehan, pastor; and Rev. Joseph Zito, assistant; (back row) Helen Gardella; Louise Zamarchi; Lena Amari; and Rose DeGrandis.